Approaching the Magic Hour

Memories of Walter Anderson

Approaching the Magic Hour

Memories of Walter Anderson

by *Agnes Grinstead Anderson*

Edited by Patti Carr Black

UNIVERSITY PRESS OF MISSISSIPPI
Jackson and London

All artwork in this book is by Walter Anderson.

The paper in this book meets the guidelines for permanence and dura-
bility of the Committee on Production Guidelines for Book Longevity of
the Council on Library Resources.

Library of Congress Cataloging-in-Publication Data
Anderson, Agnes Grinstead, 1909–
 Approaching the magic hour: memories of Walter Anderson / by
Agnes Grinstead Anderson : edited by Patti Carr Black.
 p. cm.
 ISBN 0-87805-394-8 (alk. paper)—ISBN 0-87805-803-6 (pbk. : alk.
paper)
 1. Anderson, Walter Inglis. 1903–1965. 2. Artists—Mississippi—
Biography. I. Anderson, Walter Inglis, 1903–1965. II. Black,
Patti Carr. III. Title.
N6537.A48A84 1989
709'.2'4—dc19
[B] 89-5407
 CIP

British cataloguing in publication data available

Acknowledgments

This book would not exist without the encouragement and help of my family and friends. I want to dedicate it to my daughter Mary, who took my random writings home and brought them back to say, "It's beautiful. It's a book that must be." However, even before that, one of my other children, a former first-grader, Kathy Kendall, took time from her busy life to teach me to type, insisting on the value of my words. I love you, Kathy.

I thank Peggy Prenshaw at the University of Southern Mississippi for her interest. I love my always friend, Mary Stone Brister, for her preliminary editing, (I thank Sister Hicks for all that typing, too) and for calling the book to the attention of Patti Black, who has been to me as Maxwell Perkins was to Thomas Wolfe, my friend and my mentor.

I must mention, too, the support of my brother-in-law, James McConnell Anderson, who wandered gently down the road a hundred times to see how I was doing. Thank you, Mac. To my nephews and nieces who did not deny me goes my gratitude. I acknowledge, too, the grandchildren, espe-

cially Rosalie and Moira, who sorted, transcribed and dated those 1800 pages.

To our children, Mary, Billy, Leif and Johnny, go special affection and thankfulness because they did not object but nudged me on with constant small reminders of the wonder of life.

Blessings on you all—
Agnes Grinstead Anderson

I am grateful to Agnes Grinstead Anderson for the opportunity of working with her powerful and moving words, and to Mary Anderson Pickard for her generosity in spending the time and effort to assure us both that the final manuscript reflected the original intentions of her mother. I am indebted to Mary Brister for the initial transcribing of the early handwritten memoirs and the preliminary editing of the chronology; to Frances Hicks for assisting in transcribing and typing; and to other friends—Beth Jones, Kay Child, and Leslie Myers—for encouraging me during the three-year project. Finally, I am grateful to Walter Anderson for transcendent moments, "all part of the divine symphony."

Patti Carr Black

Introduction

by Patti Carr Black

Since his death in 1965, Walter Anderson's art has been seen by widening audiences. In recent years his work has come to the attention of art critics and historians on the national scene, assuring his place in American art. John Russell of the *New York Times* wrote in 1985 that Anderson's paintings "have a quietly exultant power that puts them among the best American watercolors of their date." In *Art in America*, Lawrence Campbell wrote that Anderson's "originality merits him an honored place in the history of American 20th century art."

Anderson's work has been compared to European masters. John Paul Driscoll, art historian, wrote: "The interest Anderson had in pattern and color places him in the general sphere of Matisse and Picasso and an heir to the generation of American painters which included Charles Demuth, Charles Sheeler, and Stuart Davis." Edward J. Sozanski, reviewing a 1985 exhibit at the Pennsylvania Academy of the Fine Arts, wrote in *The Philadelphia Inquirer*: "His paintings are like Van Gogh's in the way they bombard viewers with more

visual information than they can handle comfortably. Even though modest thematically, they project a grandiose, intensely poetic interpretation of the natural world."

Anderson created a staggering quantity of work. He worked in oils, watercolors, pen and ink, pencil. He sculpted in wood, carved pieces of furniture, created ceramic figures, carved and decorated earthenware, cut large linoleum blocks for printing panels and friezes, designed textiles, and painted murals. His reputation today is based primarily on his extraordinary murals in Ocean Springs, Mississippi, and thousands of brilliant watercolors that he produced in the last eighteen years of his life.

For Anderson, art was not a product but a process, a means of experiencing the world. His significance in the history of art may lie in his perception of fundamental reality: the interconnectedness of the world, the dynamism of matter, the knowledge that man is a participant in nature rather than an observer. Anderson's art was always an attempt to create images of the underlying order of reality and his work is filled with the exploding energy and vibrancy of the universe. His role as an artist was to relate "the parts to the strange and transient unity." As a visual statement of the reality he perceived, Anderson's art offers us a comprehension that few philosophers, artists, or scientists can match.

Walter Anderson

Walter Inglis Anderson, called Bob by his family and friends, was born in New Orleans on September 29, 1903. He was the second of three sons of Annette McConnell and George Walter Anderson. Annette McConnell's family had made significant contributions to New Orleans through several generations. Her grandfather, Samuel Jarvis Peters, still is known as "the father of public education" in New Orleans. Her father, James McConnell, was a prominent attorney and judge. Annette's marriage to George Walter Anderson must have

seemed an appropriate union. A native of Scotland, George Walter Anderson was the grandson of the Lord Mayor of Glasgow. He was educated in Switzerland and came to New Orleans as an international grain exporter. Their three sons— Peter, Walter, and Mac—grew up in the Garden District of New Orleans, encouraged in the arts by their mother who had studied pottery at the famous Newcomb College School of Art and painting with J. Alden Weir in Connecticut and William Merritt Chase in Pennsylvania and Massachusetts.

In 1918 Annette Anderson bought a summer retreat overlooking Biloxi Bay in Ocean Springs, Mississippi: an 1840 house with a cottage and barn, surrounded by twenty-six wooded acres. She gathered artists together to work there and she took her sons there to spend their summers. In 1922, after Mr. Anderson's retirement, the entire family moved to the Ocean Springs property to live. Mrs. Anderson helped her eldest son, Peter, establish Shearwater Pottery there in 1928, and Mr. Anderson became the pottery's first business manager.

The Andersons gave their sons solid classical educations. At the age of eight, Walter was sent to St. John's School in Manlius, New York, which he attended for seven years. At the age of sixteen he returned to New Orleans, completing high school at what is now the Isidore Newman School. In 1923 Walter enrolled in the Parsons Institute of Design in New York, then transferred the following year to the Pennsylvania Academy of the Fine Arts for a five-year course which ended in 1929. He made an outstanding record there, winning more faculty awards than any of his classmates. In 1927 he won one of the coveted Cresson Traveling Scholarships for travel abroad. He chose to go to France and visited Paris, Fontaine-bleau, Chartres, and Mont St. Michel. He walked to the Dordogne region and into Spain, where the Paleolithic cave paintings made a lasting impression. When he came home from his trip to Europe, he joined his family in Ocean Springs.

Agnes Grinstead

The first summer after his return, Walter Anderson met Agnes Grinstead, a young woman whose family owned a summer place at nearby Gautier, Mississippi. Sissy, as she was called, was born January 6, 1909, the daughter of Marjorie Hellmuth and William Wade Grinstead. A native of Louisville, Kentucky, William Grinstead had practiced estate law in Chicago after his graduation from Harvard Law School. At the age of thirty-nine, he was advised to go south for his health. He went to Ocean Springs where he met and soon married Marjorie Hellmuth, a young Canadian whose mother had moved to Ocean Springs with her second husband, a real estate speculator. Marjorie's mother, Agnes, had gone to Hellmuth College in London, Ontario, Canada, from her home in Chicago. There she met and married the younger son of Bishop Isaac Hellmuth, founder of the college.

William Grinstead bought his bride Marjorie a pecan plantation and home on the Mississippi Sound at Gautier. He named the place Oldfields and for thirteen years he raised pecans, oranges, and grapefruit there. There two daughters, Pat and Sissy, both were born in Gautier. During the girls' early childhood, they spent their summers taking cruises from Mobile to New York and visiting relatives in Canada and Louisville, Kentucky. In 1919 the Grinstead family moved to Pittsburg, Pennsylvania, for William Grinstead to resume his law practice. After the move, the family spent their summers in Gautier. At the age of fifteen Sissy, with her sister Pat, went to France to study for a year at the Lycée de Jeunes Filles at Versailles. The following fall both girls enrolled at the Sorbonne for a year of collegiate study. In 1927 Sissy entered Radcliffe College, and in the summer of her twentieth year she was introduced to the artist Walter Anderson. From the day they met, she was swept into the vortex of his energy and passion.

The memoirs

Sissy Anderson had a life-long habit of keeping journals, which she destroyed periodically; yet the act of writing imprinted in her memory events, emotions, conversations. After Walter Anderson's death, she began in 1966 to reconstruct her memories of their life together, writing for over twenty years. The memoirs—some 1,800 pages—are a remarkable body of work. They cover family history, the chronology of Anderson's boyhood, the story of their courtship, marriage, and life together; Anderson's philosophies and passions; his outlook on history, mankind, and nature—all set against the pervasive impetus of his art.

Editing the original pages into a book-length manuscript became a quest not only because of the importance of Anderson's art, but also because of the strength and beauty of Sissy Anderson's writing. The task of editing became one of difficult choices: to select out of the great body of material the central threads and follow them. The relationship of Bob and Sissy clearly was the warp beam that held the tension of those threads. Their life together and Anderson's art are interwoven.

An intense, almost superhuman, effort to "realize" the world through his art drove Walter Anderson. This great spiritual need came to dominate his life and the life of his family and to set up within him a relentless struggle between the demands of his art and his obligations to family and society. Sissy Anderson's life became a struggle to understand his needs and compulsions as an artist and to accommodate her life to his necessity. These memoirs are the story of their separate, interdependent struggles.

It is approaching the magic hour before sunset when all things are related . . . light in everything . . . no lost places disappearing without definition . . . everything needing to be considered in relating the parts to the strange and transient unity.

The Horn Island Logs of Walter Inglis Anderson

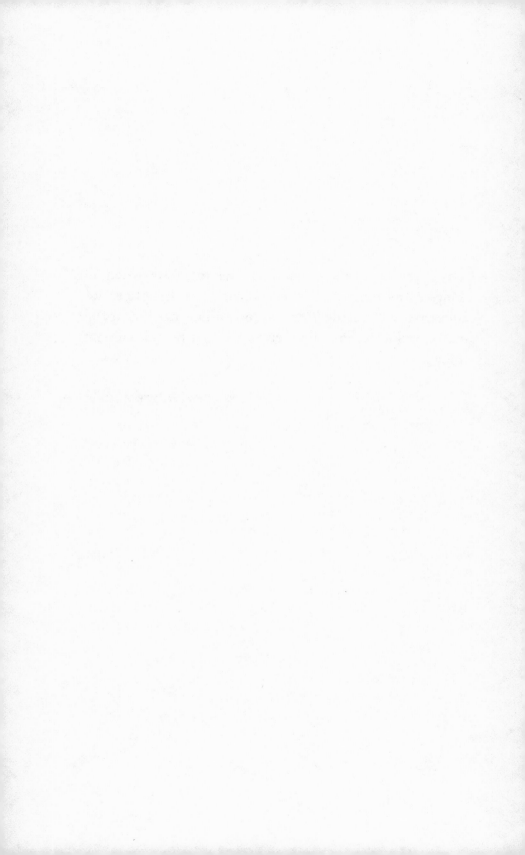

Chapter One

It was the summer of 1929. I had finished my sophomore year at Radcliffe. Instead of going home to Pittsburgh, I went south to meet my parents at our summer house in Mississippi. My train, L&N Number One, pulled into Gautier one Saturday evening in June. The wonderful feeling of contentment began in Pascagoula as we crossed the long bridge over the marsh with its smells of salt and creosote. How I loved summers on the Mississippi coast!

I remember that I was sleepy on the way home from the station and I barely listened to my sister's excited talk about the Andersons. Through my drowsiness, it dawned on me that my sister Pat was in love with Peter Anderson, who had started Shearwater Pottery in Ocean Springs, a nearby town on Biloxi Bay. I had been to the pottery the fall before and had bought a vase for my room at college.

"Peter," Pat was saying, "he's the potter, and his brother Bob does the decoration." She chattered on. "His name is Walter, but they call him Bob. He's an artist—a *real* one. He studied at the Pennsylvania Academy and in France." I came

awake. I had just decided to be a fine arts major at Radcliffe; I was enchanted with the notion of art.

When we arrived at Oldfields, our house on the Gulf of Mexico, I went straight to bed. Late the next afternoon I heard Pat calling, "Sissy, you've slept long enough. Put on your bathing suit. The Andersons have been here for ages and we're going for a sail."

Half asleep, I got up and put on my old red bathing suit. When I came out the door at the end of the gallery, two boys were sitting on the steps. I walked slowly down the gallery, adjusting the strap on my bathing cap. One of the boys, sitting with his back against the big pillar, looked up. His hair was dark and curly, his eyes rather narrow and deep blue. He had a mobile mouth and big nose. A second boy with golden curls and green eyes stood nearby. This was Peter. Walter Anderson, the dark–haired boy called Bob, stood and bowed over my hand. Bob was then in his mid–twenties. "It will be very restful to sail," he said. "Peter is a wonderful sailor." We walked quickly to the gate and down the long pier, silent and aware.

My summer at Oldfields was short that year, but we spent part of every day with the Anderson boys. They were beautiful days. We went on swimming parties and picnics; we explored the countryside; we sailed the bayous and the sound. Any occasion was an occasion for song. Bumping over country roads, sailing over water, rough or smooth, sitting on a bluff above the river, lying on the end of the pier, the Anderson boys—Peter, Bob, and Mac—burst into song. They knew everything: hymns, folksongs, opera, and musicals. Each had a specialty number. I can hear Peter now on "The Road to Mandalay," Mac on "Old Man River," and Bob doing "Water Boy."

At the end of the summer Pat became engaged to Peter, and my family, wishing for more time, sent her off to Paris to study music. I went back to Radcliffe.

In April of the following year Pat and Peter married. That

summer, when I was again in Mississippi, Bob and I were thrown together often. He both fascinated and frightened me. One hot day when I was napping in the cool hall at Oldfields, my mother shook me awake. "Bob Anderson is coming up over the bluff from his boat." I heard Bob's voice, which was extraordinarily low, asking for me. When I went out, he invited me to go for a walk. As we set out, Bob dashed around the end of the house out of sight, then stopped so suddenly that I ran right into his arms. "I love you," he blurted out, "I want you to marry me."

I was startled and backed away. He groaned and fell on the ground as if so weakened he was unable to stand. He beat his balled fists on the dirt.

My heart was leaping about. What could I say? How could this be love? I had not even thought about such a thing. Suddenly he was on his feet again, coming close, pleading passionately. I turned and fled.

When he caught up, he was breathing hard. "Promise me that you'll think about it. Promise."

"I will. I will think about it," I promised.

We skirted the pond. Dragonflies were dipping above it. Some of them were coupled, and I blushed. "Is that what you're afraid of?" he asked. "I would never push you, never." Then, "The color! Look at the color of their bodies."

I had always loved the color of the dragonflies. We sat down on a little grassy bank at the end of the pond. He pulled out his sack of King Bee tobacco, a small book of Riz-La papers, rolled a cigarette, and handed it to me. Then he rolled another and lit them both. It was my first King Bee and I rather liked it.

We smoked in silence. Suddenly I smelled the odor of burned flesh. He had pressed the coal at the end of the cigarette against the flesh of his clenched palm. He never flinched. A terrible shiver of wonder went through me.

Emotionally, I was very young. I liked romance vicariously. None of my casual contacts with the opposite sex at

college quite prepared me for Bob. All summer he courted, now charming and winning, now tense and passionate. Each time we were together there were sparks. He seemed mysterious and unpredictable.

One night as we lay on a bank above the Pascagoula River, Bob suddenly asked, "Why are you so afraid of the dark?"

"I am not afraid of the dark," I lied.

I had grown up with an all–pervading terror of the dark. I had hidden my fear for years, but Bob knew. I felt him stir beside me; when I reached over he was gone. "Bob!" I cried. "Where are you?" There was no answer. I sat up, tried to focus in the blackness that surrounded me. I felt cold all over.

"You took the light!" I wailed into the night.

Fury welled up. I would find my way to the car. I would never speak to him again. I got to my feet, trembling and unsteady. I was terrified. As I groped along the bluff of the river I tried to visualize the ragged path we had used through the old burying ground, and I turned in that direction. I sensed he was near, but I would not ask for help. I began to run. Briers wound around my ankles and I fell again and again. Suddenly there was no earth beneath my feet and I found myself in the narrow confines of an open grave. As I lay there moaning softly, Bob's hands were reaching down to me.

"Come on, get up. It's all right. I'm here." He pulled me out.

"I *am* afraid of the dark," I said. "And I think my ankle may be sprained."

He picked me up in his arms and carried me to the car. At his mother's place he washed the dirt and blood from the swollen ankle, taped it carefully, and kissed me. "I'm sorry," he said. I heard the tremor in his voice and felt it go through his entire body.

I was puzzled over this incident for a long time. When I think back on it now, it seems to me to be a metaphor of our lifelong relationship: Bob wanting desperately to give me

his sense of wholeness in the universe, to strip away my fears and make me see with my whole being, to give me inner light.

One day toward the end of the summer, when we were out in the small sailboat, he said suddenly, "I am desperately unhappy."

My eyes filled with tears. "I wish I could help you," I faltered.

"You can," he cried. "Just love me."

"But I do love you," I said, "only quietly, brotherly, not the way you want."

"You are afraid," he accused. "I'll make you love me." He leaned over and kissed me. "Marry me," he pleaded.

I pulled away. "I like quietness and tenderness, Bob. You make for violence and storms."

Almost fulfilling my plaint, he replied, "Can you get back home? I am going to drown myself."

His face, a healthy sunburned face, showed white beneath. He was breathing hard and his whole body was as taut as a sheet rope in high wind. Such passion makes its own claims; I heard myself agreeing to become engaged.

"Then I must ask your father," he said.

My father, the kindest and most courteous man in the world, did not like Walter Anderson. It was difficult for Bob to ask. He knew my father would say, "No," which Daddy did, with considerable force and scorn. "How will you support her? Come back in a week and tell me what your plans for the future are, and I don't want you to see each other until then."

The Andersons' old Ford touring car rattled and bounced away. Bob went home and came back in the specified time, hollow–eyed, with a document setting forth his financial worth, which included five years of training in art, his share of the place at Ocean Springs, and some money that had been left him. He had plans for a workshop and muffle–kiln to be paid for by the small inheritance, and two designs

for figurines, which he called "widgets," to be manufactured and sold in quantity. He even listed places to buy clays and colors.

My father weakly gave his consent to an engagement, but within days I was shipped off to relatives in Louisville, Kentucky. From there I returned to Radcliffe to find a stack of missives from Bob that prompted my immediate response. The passion of his letters overwhelmed me. I demanded that he stop writing altogether unless he could confine himself to ordinary communications.

He wrote back in an entirely new way, describing the weather and appearance of my beloved Mississippi coast. Through these letters I saw Bob with fresh eyes. He was a poet, and an artist. I began to feel that I *was* in love with him. He wrote news of his venture in pottery. He had persuaded his younger brother, Mac, to pool resources to build an annex to older brother Peter's Shearwater Pottery. They had launched a highly successful business by January of 1931.

Bob already had a fairly well–developed theory of an artist's obligation to society. He felt this work would fulfill for him the duty of an artist to produce inexpensive but good works that would provide satisfying decoration for the home of the average man. All this was conveyed to me in those letters that year. Taking me at my word, because his was unfailingly what he meant, he ceased to mention his "passion," as I had called it, feeling very daring for using the word. Perhaps I missed some of the words of love, but I wore his grandmother's engagement ring and read his letters and shivered.

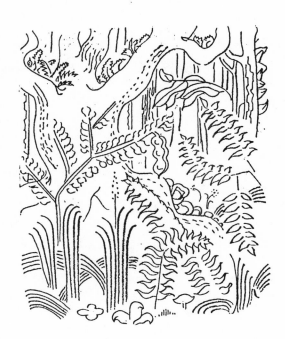

Chapter Two

My senior year came to its close and I returned to Oldfields for the summer of 1931. It was the year of the honeysuckle explosion. The whole world seemed to have been taken over by the vine. It was a smothering feeling and I had a terrible desire to pull it ruthlessly from every shrub and tree. Bob laughed at me, picked a spray, and made me look at it with him. Of course it was beautiful, the most beautiful thing in the world at the minute—a long, perfectly designed stalk with evenly spaced leaves and marvelous white horns. I pulled off one of the little flowers with a child's care, put the stem tip to my lips, and sucked out the sweet drop of nectar.

"What are you doing?" he asked. "Would you like to destroy it all by eating it?"

Was it possible that he didn't know about the drink of the gods that one could get from the honeysuckle's flower? All children know that. I took off another flower and put the tip to his lips. "Suck."

He sucked and smiled, and said, "Who was it who ate

his children in the old Greek myth?" How active his mind was, and how quick to draw analogies. He was so continually delighting me that my mind spent itself trying to keep up. His unconscious was far closer to his conscious than that of ordinary people; ideas constantly bubbled up and surfaced.

On a night of the full moon we were lying in the sand on the bank of one of our less traveled creeks. We had borrowed the old Ford and traveled the Vancleave Road north to the creeks where the feel of fall seemed to come early and where the water of the creek was cool with the night's north wind. In the black water we had soaked until we were chilled. It was a dark night and all my thoughts were of love. Suddenly, like a helium-filled balloon, the huge full moon shot up above the trees. It was bright red. He whispered in my ear:

> "When fishes flew and forests walked
> And figs grew upon thorn,
> Some moment when the moon was blood
> Then surely I was born."

I had no idea what he meant. Suddenly I spotted the silhouette of the anhinga on the branch of the cypress tree nearby. I knew at once that he had probably watched the bird light long before, and there he saw his flying fish and all of prehistory, for the anhinga is a relic of very ancient times.

"What are you quoting?" I asked.

"Chesterton!" he said, lying beside me, a thousand miles away.

The climbing moon turned silver. Suddenly the bird gave an unearthly croak and dove toward the water. The wings, close-folded against the cigar-shaped body, did not unfold. As the long-toothed beak hit a sunken log in the water, the sound was horrible.

"My God, I hope its neck is not broken!" was Bob's anguished cry, and he was into the water after the anhinga. He came back to the sandbar bearing the long, shiny, limp body

in his two hands. A trickle of blood was running down the supple neck. He laid the creature in my lap. " See if you can feel a heartbeat," he begged.

I shook my head.

His cry was like a sob. "It's dead!" He took it from me and put it on a drift-log that was bobbing along in the creek's current—a Viking burial, without the flames. He grabbed my hand and pulled me rather roughly through the huckleberry bushes to the path, and we went silently back to the car.

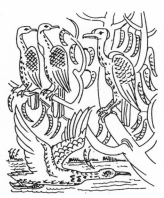

Though Bob and Mac worked hard that summer in the little industry that they had started, my father still maintained that the income was not sufficient for marriage. He carried me off to our home in Pittsburgh and there, in the spring of 1932, Daddy, who was sixty-six years old, suffered a sudden mental collapse brought on by hardening of the arteries.

My mother took him south to Oldfields, and after I had closed the Pittsburgh house I followed. We were never to return. From Oldfields my mother took my father to a mental hospital near Baltimore, and she rented a small apartment nearby. I closed Oldfields and went to Ocean Springs to stay with Pat and Peter in their spare room in the Front House at Shearwater Pottery.

Bob was also living on the pottery grounds, and he and I grew close. In April of 1933 we were married. I was twenty-four; Bob was six months away from being thirty.

We went for a week's honeymoon to Oldfields. It had been closed since the day I left it. We arrived in the early afternoon and opened doors and windows and made up the big double bed with sheets kept fresh by a cheese-cloth bag

full of dried deer tongue leaves in the linen closet. While I trimmed and filled the kerosene lamp and looked for candles, Bob found a stack of old *National Geographic* magazines in the attic. We ate our supper, brought like a picnic from Ocean Springs—sandwiches of peanut butter and jelly, strawberries and milk brought by the farmer who took care of Oldfields, and Oreo cookies.

Night breathed about us and still he was looking at old *National Geographics.* When would the moment come? Was he sorry he had married me? Was there to be no consummation of the marriage? I shivered in the lamplight and went to get a blanket for the bed. When I came back, the *Geographics* were gone. Bob had taken off his clothes. Now he removed mine and covered me with kisses and little bites. He blew out the candle and covered me with himself, making hoarse but tender noises. The sigh that came from him—was it agony or repletion? Had he found the union, the oneness, he desired in those few brief moments that were to me agony?

Three more times that night he turned to me. I strained against him, trying to respond. At last, groaning, he left. He walked over the bluff to the sea, and I felt that he was gone forever. I wondered if his body would be found. I sobbed, face down in the bed, tears like gashes of heat pouring from my eyes. I knew there must be a response to the shower of gold, an answering cackle from the swan, a bellow for the Bull from the Sea. I had failed. I had sent him to his death.

In the morning he returned, cold and reserved. "I must have swum almost out to the beacon last night in the moonlight," he said. "It wasn't so cold. You should have come along."

Later he suggested that we walk down the beach while the tide was out to look for arrowheads at Graveline, where the old mounds were being washed into the water. I did not tell him that my body was stiff and sore. As we walked the exercise limbered me up.

"You're not so stiff now," he said, taking me into his

arms gently there on the deserted beach. He always knew everything before I could tell him.

Going back down the beach we found seven shining arrowheads on the sand and filled an old Luzianne coffee can with dewberries, big ones, rounded and black, to eat for supper. We ran down the last stretch of beach like children.

As soon as we got home he took his clipboard and began to draw. No wonder his lips were so hard and so mobile; he used them in an extraordinary manner as he worked, mouthing each stroke of his pencil. He used a squarish dark green Venus pencil with a tremendously thick lead, hacked to a partial point with a knife. How could he make such contrasts of fine and thick lines with such a crude instrument? I was beginning, most surely, to think worshipful thoughts as I saw the curling lines of dewberry vine coming to life on the paper, and the separate and fantastic shapes of the leaves. Pattern, the feeling of space—how beautifully he did it!

When he was work-ing, I might just as well not have been there, so I got paper and began to write verses. I fell asleep to the gentle and swelling sound of Brahms's First Symphony, which he hummed—one motif—over and over as he worked.

The third day of our honeymoon we went to New Orleans. I had a small green Chevrolet convertible that my father had given to me when I graduated from college. I loved the car with a little girl's attachment to a favorite toy. Bob liked it, too, but I never enjoyed having him at the wheel of a car. He had an insouciance about his driving that went deep, a lack of respect, almost a dislike, for motors of any kind. The result was careless driving that made little deference to other vehicles or to the speed at which he proceeded.

We left Oldfields at dawn. He drove rather quietly as far

as Ocean Springs, then through that sleeping town very fast, across the old Biloxi bridge, and out to the beach. He watched the distant islands beginning to emerge from the pink pearl sea and vaporous horizon. "Cat Island!" he cried with enthusiasm. "Look at it. The island is full of coons. Doesn't it seem miraculous that some coon long ago dragged itself out on that sandy beach and managed to live? I think they floated out of the river, at flood, on a log, and made the passage as if they were in a boat. They were there when the French landed. The French sailors thought they were cats— wet and dripping. Life must have been precarious for such a woodsy creature."

Yes, I thought, and life's precarious for us right now.

After Bay St. Louis we plunged through the Honey Island Swamp. The sun was up now. All the birds in God's creation were up and out that morning. Wheeling, flitting, perching, they drew Bob's eyes like magnets. He had a strong affinity for birds.

"Oh, see the prothonotaries!" he would cry. "Listen, hear that liquid trill. It's easier to hear them than it is to see them. Oh, look, I think that's a blue-gray gnatcatcher in the willows, can you see?"

I, alas, was not very good at seeing birds, especially from a fast-moving car. "Let me drive," I said. "Perhaps you can see better."

"Oh, no, this is fine. Up above, up above! They look exactly like Mississippi kites. . .they are, oh they are!"

We stopped at last in downtown New Orleans. He wanted to exchange a wedding present we had received from his favorite cousin, a lamp that did not go with the simplicity of our "cottage." What should we get instead? Money was very scarce with us, but we bought copper goblets because Bob liked their shape and color. He took me, in most courtly fashion, to lunch at Kolb's. Then we went to Farish's, the artists' supply place. He picked his paints very carefully—all the colors he loved the most. The clerk knew him well, antici-

pated his needs, and called his attention to a magnificent magenta and to a lemon yellow that was pure light. I felt very important having an artist for a husband.

All the long way home he sat driving like a stone, thoughts so far away or so terribly occupied that he did not see the same wonders that had delighted him on the way over. We got back to Oldfields after dark and went straight to bed. He slept at once and deeply until morning.

"I'm going to Ocean Springs," he said. "Do you want to go?"

"No, I think I'll stay here," I answered. I knew it was what he wanted.

Later, his mother told me that he had come to her.

"I am a painter," he told her. "Why do I have to make silly figures in clay? I am a painter. I *must paint.*"

She tried to tell him that he could do both, but he knew this was not true.

That night Bob wanted to talk. He said that I was the first girl that he had really loved. He told me that he did not know what girls felt about sex, and that I would have to forgive his mistakes. He told me about his prostitute in Paris, where he studied art. Then he said, "I do not want to have children, ever. I would not want to bring a child into a world so filled with pain and terror. That's why we're using birth control—not because of financial reasons. Do you mind?"

Did I mind? Pat and Peter had a second baby, a beautiful little girl. The two babies were enough for me. I whispered quite happily, "Of course not—not about having children. But I mind terribly your feeling that way about life. What about the times of ecstasy? What about the summer days? What about flowers? What about sailing? What about painting?"

"*That* is an agony," he said, and blew out the lamp and turned on his side.

Chapter
Three

The Andersons presented Bob with the cottage as a wedding present. It was a typical coast cottage, white clapboard with a steep roof and attic, a big screened porch on the front, and two small rooms around a central fireplace. The back porch had been made into a bathroom, kitchen, and studio area. The bathroom was partitioned off, but the studio area, which faced north and had glass from floor to ceiling, was one with the kitchen.

My mother gave us a kerosene stove from Oldfields and an ancient icebox. Someone gave us a card table. We slept for a few nights on a studio couch sent by my mother while Bob made a boxlike bedstead with the greatest care. He loved making furniture and had a gift for it.

He was hard at work at the pottery. Most of the widgets, small ceramic figures, had already been designed. There was an established routine at the pottery. Bob left the house about eight-thirty in the morning and walked out the road to the workshop. There were always a hundred things to

catch his eye—from an ant on the giant purple vetch flower to a small white egret in the marsh pool. But there was no stopping to translate these marvels. He had to mix slip, cast molds, trim figures, paint models in underglaze. He did not mind work.

I remember when he came in for his first noon meal. His eyes were shining, and he was thrilled by a new widget that his brother Mac had made. It was a banana bearer from the New Orleans docks, and we were very excited.

By one o'clock he was always back at the workshop, having successfully avoided the temptation of a siesta. It was 1933, and the country was struggling with the Great Depression and unemployment. The state of Mississippi was bankrupt. Money was scarce for everyone, but Shearwater Pottery managed to survive. Bob and I had ten dollars a week to live on. Out of it we had to pay for heat, light, food, clothes, medicine, recreation, and the luxury of a cleaning man once a month. It was not long before we realized that it would not support a car, the one my father had given me. We sold it and bought bicycles.

Bob came in from the workshop at four most afternoons. He was tired, but we often worked until late at night on furnishings for the house. After the bed, he made a table. We traveled far up to sawmill country on the Pascagoula River to find a single wide plank of cypress. This was not easy, for most of the huge cypresses had been cut from the swamps before the 1930s. We borrowed his mother's old Ford and drove above Moss Point to Dantzler Mill, where he spent hours searching through piles of discards. He dug a few good short pieces out for table legs.

"Why must they be so thick?" I asked.

"I want them to express the feeling of the tree," he said. "Have you ever seen a really big cypress standing out alone in its majesty in a swamp full of lesser trees?"

An old man came over and learned that Bob was looking

for a table top. "My cousin got a little mill up close to Wade," the man told us. "He got one or two big old trunks left. I reckon he might cut you what you looking for."

Bob was like a hunting hound as we looked for the old mill, which we found by luck. The trunk was there, and soon the saws were buzzing to cut the plank.

"A magnificent plank," Bob called. "Perfect. There'll be enough for chairs, too."

We both worked over the table, separately and together. It was rubbed, sanded, rubbed again, and waxed until it shone like butter in the sun and felt like satin. Next came the chairs and, as he had with the legs of the table, Bob made them in a cut-out design so that they were like thrones. He finished them in rubbed-off red, which he thought fitted them. We sat on them like king and queen when we were in the cottage.

After the chairs and table were finished, he decided to paint curtains for the cottage. The house was almost in the woods and we both loved being able to watch the birds and other creatures. To frame the windows, he cut very narrow curtains and painted on them with oil paints concentric half-circles, alternating from side to side in blue, magenta, and black. The effect was wonderful.

We did not lack for ornaments, from the pottery shop, but Bob decided we needed a rug, so out came the clipboard. Hooked rug designs lay all over the floor for days.

"This will be fun to do at night," he said. "We can take turns. One of us can hook while the other reads aloud."

I was never good at hooking, so I usually did the reading. I read *Look Homeward, Angel* and William Butler Yeats. The rug yarn was heavy and Bob's punching was often vehement. The rug grew apace, as did most of his work. Physically, he was a quick person. Repose was never a part of him. He did not actually know how to rest. Even listening to music, his body made a physical response. My uncle had given us a radio for a wedding present and we used it night and day. Bob loved

16

to dance, interpreting the music with inventive movements.

We never missed the New York Philharmonic's Sunday afternoon concerts. It was our day for bicycle trips and picnics, but we *had* to be home for that. Sometimes it took fast pedaling, and Bob would shoot ahead of me at the gate and get the radio on while I was still laboring up the hill. I listened to music in complete ignorance and utter bliss, from an emotional standpoint. Bob listened in complete bliss, but with an intellectual joy. He was always connecting tone with color and rhythm with pattern, until I think he saw a Beethoven symphony almost as he would see a painting or a series of paintings matched to the movements of the symphony.

For supper in the evenings we worked out a pattern of food with due regard to ten dollars a week. Sunday night supper was hearty: a French onion soup that we invented ourselves, a bottle of wine, and fruit for dessert.

The first months of married life flew by. I was learning to cook and keep a house and be a wife and take care of a man. I was very much concerned by my feelings and by the slowness of my responses and by the lightning swiftness of his. He did not seem to be concerned at all.

I was willing to practice birth control because of the economy, but on a temporary basis. Bob renewed his vow never to bring a child into the world. I could not believe that he felt the world was Hell and life was agony, because his enthusiasms were so extravagant. I had been brought up to believe unquestioningly in a God who was good in every way, and to revel in the beauty of a perfect world. I *did* believe *that*.

July came, with its terrible heat. A telephone call from Baltimore summoned my sister and me to the bedside of our dying mother. A massive cerebral hemorrhage had left her spent and hardly able to speak, but she whispered to me with her cracked and swollen lips, "Are you happy?"

"Oh, yes, Mamma."

She died the day after we got there, and we brought her home for burial. After the funeral we brought my father down from Baltimore and made arrangements for him to live, with attendants, in a small rented house in Ocean Springs.

Bob and I, like most married couples, struggled along. Now blissful. Then heartbroken. My life in Ocean Springs was busy. I sold pottery at the Shearwater Show Room. I kept house and did a small amount of writing. I worked in the town's Soup Kitchen and went to the Episcopal Women's Guild with Bob's mother.

Three years went by with this sort of life—Bob struggling with the business of earning a living and producing one delightful series of figurines after another. A favorite one was named for the medication that gave him relief from rather desperate headaches. "Mr. Aspirin," one of his molded figures, was a left-handed (he forgot the reversal of the molds) minstrel man playing his banjo and wearing his top hat and gaudy clothes. He was a lamp base, and a figurine of beauty. I almost welcomed Bob's headaches as a harbinger of creativity, but this was a mistake. Later I was to see that they were probably a sign of tensions growing greater than he could bear.

Bob created all kinds of incredible decorations for pots. Most of these pieces were sold as more and more people came to the show room to buy his carved and scraffito bowls. His mother often seized one when it came from the kiln and kept it for the treasure it was. He was not using underglaze

18

paints for decorating, but carving deep so a difference in color could be obtained by using glazes, or using slip, and scratching back to the background. These are laborious methods, taking much time and concentration. Later he preferred the swift application of color, almost freehand, with underglaze colors.

During this time Ellsworth Woodward, a Newcomb Art School professor who had been made Mississippi-Louisiana head of the "Public Works of Art" project for the WPA, sounded Bob out for a project: murals in the auditorium of the Ocean Springs school. Bob submitted sealed sketches, which were approved, and once he was given a deadline he worked with the joy of a little boy.

One side of the mural represented Ocean Springs as an Indian boy or girl might have seen it three hundred years before. The other side showed the present-day town, its environs and pursuits. The treatment was very flat, almost like Egyptian tomb painting or Minoan wall fragments. What he was paid barely covered the cost of attaching the panels to the wall with a special adhesive. It was the work, though, that was the important thing.

Soon afterwards we were visiting Oldfields, looking out past the house and beyond the bluff to the water. How beautiful it was. The rain moved across the sky and sea like a white curtain. The sun, absent all afternoon, suddenly appeared low in the sky. The azaleas were jeweled with the drops of rain, lit from without. Bob looked almost stricken. I thought for a minute he was sick. Then he smiled and reached for my hand. "How," he asked, "could you ever make anyone see it?"

"Paint it," I answered, but he laughed. "I think you're foolish," I said. "You seem to put yourself down. Monet did it. Renoir, Sisley. You are an artist, a wonderful one."

"When could I paint?" he asked.

These were the times when guilt would descend upon me. Was it because of me that there was no time for painting,

that he had to struggle with the clay and the plaster and the kiln, the abominable business of making a living? I wondered again and again what would happen if I took things into my own hands and went to work. I was sure that I could get a teaching job. My sister thought it would make Bob feel like a failure.

His mother sputtered, "What do you need that Bobby isn't giving you? People put entirely too much emphasis on material things. If you could just look at it properly, you would see that you have everything, far more than just enough."

Then she muttered something to herself, but I caught it. ". . . brought up in Pittsburgh. . .banker's daughter. . ."

It infuriated me, and so I found the courage to talk back. "Oh, Mère," I said. "I do have everything I want and more. It is Bob who's missing the most important thing of all—time to paint!"

It was then that Mère realized we had a meeting of the minds, and our close relationship lasted to the end of her life. We never again had a moment of mother-in-law friction.

"Bless you," she said.

I went home that day walking on air.

I was completely wrapped up in Bob. I try to think back to that time. I was very happy. I wanted nothing else. Friends laughed, "When Sissy swears, she says, 'Bob damn it.' "

Did I really think of him as God? I hardly think so, but I knew that he represented something far superior to the ordinary human herd. I thought of him always as being like Jesus, a strange comparison, because he did not truly fit the bill. He was subject to fits of black depression; he could not be bothered with people who bored him. It must have been the tremendous creative surge that gave him his godlike quality. He knew things not only by observation but by a sort of intuition, a sort of basic and far-reaching knowledge that he himself was later to define as the ability to become one with any living thing—tree, flower, ant, bird, man. How much I

did learn and what happiness I enjoyed. But increasingly there were times when he wanted to be alone. Already he was seeking in nature the things that he needed.

One day in the fall he did not come home for lunch. I waited. After a while I went down to tell Mère. The Andersons lived in a house that had been converted from a barn that was on the property. "Probably not hungry, or else very absorbed in his work," she said. "Artists get that way, you know. You'll have to get used to Bobby."

When at four he still hadn't come, I waylaid his brothers. "Where is he?" I implored. "Where is he?"

"He didn't work today," Mac drawled.

"Seems to me I saw him go out the gate this morning," Peter told me, hoisting little Michael to the handlebars of his bike and speeding off.

What was I to do? Nobody else seemed to worry. "Mère, he hasn't come home yet." It was dark now. A rising panic choked my voice.

"Don't worry," she said. "Bobby will come back."

"What if he needs help somewhere? What if he's been hurt?" I said.

The night seemed endless. As the predawn whiteness spread across the sky, I suddenly smelled the peculiar and distinctive odor of marsh mud, and there was some other acrid scent—ah, it was guano, seabird smell. Up on one elbow, I tried to see where it was coming from and was startled by Bob's immediate presence. He was taking off his clothes, soaked and stained, just outside the screen door.

"Where in God's name have you been?" I sobbed.

"In heaven" came the whispered reply. He slipped into bed beside me, asleep before his head touched the pillow.

The morning went by with my guarding his rest and seething with all the things I planned to tell him about his thoughtlessness. When at last he appeared in the kitchen door, famished, he was in such a shining, innocent state that I was not able to say a word.

Truly, I don't believe he ever knew what I had gone through; his magnificent experience had been the only thing that mattered. He told me about it. That day as he went out the road toward the workshop he chanced to look up into the empty space above the marsh. There, in a great drift of white against the pale blue sky, was a flock of birds, big birds. The morning sun was shining across the moving wings; they were flying east into the light. He stumbled up the little hill to the gate, keeping his eyes on them, and followed in a daze along the open road down East Beach. When he reached the mouth of Davis Bayou and looked out to Marsh Point, they were all over the Point and on the water. They were white pelicans. He wasn't close enough as he sat on the little beach, so he waded straight out, swam when the water deepened, and soon found himself among the great creatures. He watched them all day and most of the night until they flew off into the moonlight. Then, of course, he came home.

"As long as I live," he said, "I shall never forget it."

Chapter Four

For Bob, there were thousands of minor miracles waiting at each turn he took and shaking him with their wonder. I knew that he struggled with himself to share them with me.

We began to take a weekly trip, just for the day. His boat was a black inboard motorboat built along dory lines, high in the bow, narrow in the stern, wide-beamed. He built it himself with the help of Alphonse Beaugez, his old French friend whom he adored. He and Alphonse had soaked and bent by hand every plank in that boat. It was clumsy, slow, but it had rhythm, he said, so he named it *The Pelican*.

We made many trips in that boat. In August of the first year, just before hurricane time, he announced that we would take a week off and visit the offshore islands. "From Dauphin Island to Cat Island," he insisted. *The Pelican* could do it easily, but we would need time. He was haphazard in his packing. We took mostly canned food, soups and fruit, all tumbled into a gunnysack which inevitably got wet. The labels floated off and we never knew what our meal would

be. He didn't care, but I blanched when confronted with canned mackerel and applesauce, or sardines and sliced peaches.

"We'll go to Horn Island the first evening," he said, "and leave there in the early morning for Dauphin." Since Horn Island was about twenty miles east and Dauphin Island was near Mobile, some fifty-five miles south, it meant a long trip. Off we went, with a large piece of canvas which Bob had rigged with two poles so that it could be stretched for a sail or doubled for a shelter. We had a tank full of gas, two extra cans, and a small pair of oars. We had water, provisions, and a small blanket roll with extra clothes wrapped in the canvas. We departed after work one Tuesday afternoon to cheers from his brothers, who were always extravagantly pleased when Bob succeeded in making an engine go.

The trip out to Horn Island was made in one of those calm translucent evenings: quiet water, sunset merely pink, a slight north breeze, and the cool feel of fall in the air. We reached the island just before dark and coasted down the inner beach, barely disturbing the birds, fish, and crabs. We took the boat right up to shore and unloaded only what was necessary. After he pushed back out to anchor, he swam ashore naked and beautiful, gleaming white in the evening light.

The island was deserted. There was not even a shrimp boat. We walked across to the Gulf beach. The surf was coming in very long and slow and the phosphorescence was already showing in bright curls of foam and streaks, as fish showed. We swam for hours, naked, and made love on the sand, and then chased the curious little late sandpipers who refused to mind their own business—beachcombing in the damp lines left by the receding waves. We felt deliriously happy and quite innocent. We did not put up shelter, but slept on a blanket under the stars just above the high-water mark on the Gulf beach until the morning light.

"This," he said, "is one of my favorite times. Watching

the stars melt into the sky as the sun's light grows stronger is like watching a miracle."

We ate a very quick breakfast of pancakes and syrup and coffee and were off with the pink still in the sky. The Pelican was running smoothly and we went slowly in order to enjoy the island's shoreline. I had been camping and picnicking on Horn Island since I was a child and loved it with a strange, piercing love, but I had never quite seen it before. Bob's eyes taught me to look in new ways. Instead of seeing the stunted, distorted pine shapes on the dunes as just so many decorative, Japanese-like forms, I learned to look at the jeweled colors of needles and trunks and the purple splash of shadows. I saw yellow-green ponds of palmetto clumps against the blue-green darkness of rosemary with its rounded, perfect shape. Sharp, sharp in the bright, hot sunlight against the white sand, the details of the island stood out. There were marvelous shapes of driftwood and animals, suddenly and briefly glimpsed; the quick bounce of a rabbit in a low place; an old pig running for the cover of a thicket; a group of cows standing in the edge of the water to get away from the dog flies; a mother coon, very businesslike, retreating up the beach with three babies. And always the birds, sea and shore birds, in glorious attitudes of flight.

When the sky seemed too brassy bright and hot, we would look deep into the clear, clear water and behold a varied panorama—stretches of greater and lesser depth, varying color, and changing bottoms: mud, shell, sand, grass, and the inhabitants of each section. The sand, in some places, was strewn with starfish or sand dollars. There were innumerable shells—big conches, stationary and bovine; busy, small hermit crabs; and fish, large and small, feeding or darting in pursuit of food.

We went ashore again on Petit Bois, an island plumed with sea oats, gold and ripe for the birds' fall harvest. Then we pushed on to Dauphin Island to scout Indian mounds.

When we left Dauphin, we headed back toward Horn Island, taking a fix on the Petit Bois light. Petit Bois light at that time was a beacon with living quarters for a keeper. He had no traffic whatsoever from the mainland, except a tender that came out with relief or supplies. We were still a good way from it when The Pelican's steady chug, chug, chug became a chug, knock, sputter, sput, and, at last, an ominous silence.

"Out of gas," Bob said cheerfully. "Put over the anchor." He brought out one of the spare cans, transferred its contents into the gas tank, and began to crank the motor. Again and again he turned it. It merely grunted. He grunted. At last he sat down and began to laugh. "It's oil!" he shrieked in merry abandon. "It's oil. All motors need oil in the crankcase. I brought the gas and forgot the oil."

"Could it use lard?" I suggested helpfully.

"Oh, no," he said. "Look over there. That's Petit Bois light." There was a dot on the distant horizon. "We'll just sail over there and buy or borrow some oil from the keeper."

He lashed the bamboo pole to The Pelican's stub and together we spread out the canvas and hoisted it as a sail. I had to hold the pole at the stub. I wound both arms and my knees around it as I clung to the bow. He pulled up anchor and we were off, scudding before a freshening southeast wind like a curled dead leaf before a boy's blown breath—and right on target. The dot assumed the shape of a beacon. Beside it was perched a small house ten or fifteen feet above the water. On a lower platform, at water level, a man was engaged in some violent activity.

When at last we reached the light, we could see that the lightkeeper was struggling with a sea monster. Bob made fast the boat and rushed to his aid. He was an old, weathered-looking man, white-haired, and he called, "Gi-da-gaff, gi-da-gaff," over and over.

"Where?" called Bob.

"In da house," yelled the keeper.

Bob disappeared briefly through the door, returning

with a long pole with a hook on one end. He hooked through the gills of the gigantic head that the keeper had at the end of his line. It took both men to pull up the jewfish—the biggest thing in fish form that I had ever seen. It lay exhausted, hardly flopping, on the platform, blood gushing from its pumping gills.

The keeper sat down beside it. Finally, his breath was no longer coming in gasps, and he said, "Ya 'appen along a' jis' da right time, ya." He told us of his battle with the giant, which had been on his line since early morning. Then he invited us into his spotless little room for coffee and took us to see the lantern of the light. It seemed to have as many facets as the eye of a great insect.

The lightkeeper was a Louisiana Cajun with a German mother, and he was so glad to have visitors that he nearly fell off his platform twice. He furnished us with oil for The Pelican and insisted that we wait while he butchered the fish. He cut off the huge head with an axe. I flinched and knew Bob did, too. The head was at least one-third of the fish and sank like a stone through clear water. We could see it rolling around with a ground swell as it moved to the bottom. Presently, gray shadows, slinking like wolves, were darting around it—sharks. He peeled the skin from the body and sliced off fillets, one of which he presented to us. How could we refuse? We left the lighthouse waving and calling our thanks and our farewells, with that huge hunk of meat reposing on my lap. We had nothing to wrap it in, nor had he.

It didn't take us long to reach Horn Island. Clouds had come rushing up out of the east and it was dark, although not quite sunset. We anchored the boat with extra care and hastily put up a shelter. Bob built a good fire and said, "Now cook the fish for supper." He was deadly serious. "We'll not waste a gift like that." He stomped off, and I realized that the fish's life was not to have been lost in vain and that we were to further its apotheosis by eating it.

We had with us a medium-sized old black cast-iron skil-

let. The fish was of a size to fill the skillet four times. The flesh was white and looked coarse and tough. Reluctantly I seized the knife and began to cut it into strips. I poured a little oil into the skillet and fried the strips, laying them on palmetto leaves beside the fire as they became brown and crisp. On and on, strip after strip, piles and piles of fish.

The sky became more and more threatening. It was as if the gods were angry that mortals had dared to interfere with one of their number. Now, the fish was finished. I heated water in the coffee pot and poured it into a bowl of cornmeal and salt, added a lump of lard, and fried a batch of corn pone to go with the fish. I made a pot of coffee and replenished the firewood. I stacked dry wood around the inside walls of the shelter. Still Bob did not return. Drops of rain began to sizzle in the fire. I put sticks of kindling on it and slanted some old gray, weather-worn planks over the food. Then I sat close by the fire until the real downpour began and I was forced into the shelter. I crawled in, being careful not to get sand on the blanket, and lay there watching the silver pencils of rain, straight and constant in the firelight. I knew that Bob had run from the noble fish's death, the wish to have no part in it or of it.

He came back naked, his body as cold as ice, and slipped into the shelter beside me as if he did not want to wake me. His back was to me and he did not speak. He was shivering and I put my arms around him to give him my warmth. When the shivering stopped, I found that he was sound asleep. The rain was beginning to stop. There was just a patter now, and the fire began to flare up where hot coals ignited the wood. At last the big black clouds were far away, low on the horizon toward home; the sky was luminous and white, and the moon was making the sands as light as day.

I could see a mother and father coon, followed by three babies, coming down a sand valley between two big dunes. Food is sparse on Horn Island. All the creatures there are lean and hungry. I felt that the coon family was better alchemy for

the sleek, darting beauty of the fish, and fell asleep while I watched the gradual depletion of the food piles on the palmetto leaves, carried bit by bit down to the beach by the marching, single-file coon family.

At dawn any remaining jewfish was disposed of by a huge old speckled sow and her brood. They were extremely noisy and untidy about it, squealing and sucking, snuffling and crunching. We both woke up laughing, made love before breakfast, and ran across the sand for a swim. Everything was clean after the rain—cool and sparkling, pristine. It was wonderful to be alive.

 Bob's passion for life was always making him adopt some oil-soaked seabird or lead-poisoned duck. His efforts to make them live were often like the labors of Hercules, and usually fruitless. But his curiosity about living things, their forms and colors, often caused havoc—like the baby pelican that, exposed too long to the sun while he painted, died before his agonized eyes.

I could never reconcile Bob's reverence for life with some of the things he did. Making a series of watercolors on the development of the embryo within the egg, he dug up the eggs at set intervals over a period of weeks. So many small creatures sacrificed to—what? Curiosity? Art? One man's desire for knowledge? All these things?

For a set of bird studies, he shot the birds and pinned them in position. What was it in this man-god—full of sympathy, full of love—that forced upon him an act that could only be characterized as ruthless? Does the act of creation become so transcendent that it can be carried out without regard for anything else? Yet I knew he suffered deep conflicts about it.

When I look at some of his paintings now, I think I begin to understand. There are two compulsions: a desire to know all there was to know about a creature and a desire to record the terrible beauty he observed so briefly—to be able, even after its death, to save it from dissolution and decay.

It was the same impulse that made him seek out creatures killed on highways to do them honor by painting them before giving them a burial. The same thing made him draw his mother as she lay dying, giving her what he could of immortality.

I'm sure he never forgave himself for capturing the sea turtle. I think it was in the spring of 1936 that the great turtle hunt occurred. It was not an ordinary fishing trip. The group was going out to the Chandeleur Islands. The Anderson boys always welcomed a trip into the wilds. My young cousins and Uncle Ted Hellmuth from Chicago were going along and were wild with delight at the prospect. Peter had prepared his boat, The Gypsy, and they were to spend three days. When they returned, they had a tremendous old sea turtle lying on her back on the deck of The Gypsy.

Twenty-five years passed before Bob told me the part of the story that only he could tell. Tears streamed down his face as he halted through the part I did not know. When they reached Chandeleur, at the little harbor where the lighthouse is, Peter and Mac took the Hellmuths everywhere and introduced them to the different types of fishing—surf-casting, skiff-fishing in the bayous, deep-sea trolling, mullet-netting. Bob went off by himself and refused to fish at all. He combed the beaches for shells and noticed quite a few turtle crawls. He hoped that by watching through the night, which promised to be lit by a very large moon, he would see one of the great creatures at her egg-laying.

"We had hoped that it was too early for mosquitoes," he said, "but we were wrong. There were hordes of them, and all the others went to bed in the boat's screened cabin. I preferred to chance it ashore in whatever wind I could find.

There wasn't much, so I tramped and swatted, tramped and swatted, and in the early, early morning, before day, I had my reward." He was lying on the top of a dune, wrapped, head and all, in his blanket. Something made him stick his head out and, even before he could see, he sensed her presence. Then he saw a form like a great rock just at the water's edge. "She looked so big I couldn't believe her. I stayed perfectly still, and eventually she melted a little way up the sand. It was the most extraordinary movement I had ever seen."

Bob said each bit of progress was followed by long rests. Finally, just before the first glow of light, the turtle reached the crest of the beach. "I have no idea why I did it, but the next moment I was upon her. I fell on her, embraced her huge form, had my hands around her neck. I had caught her. Caught her? How ridiculous. Can one catch a mountain? What would I do with her? Why hadn't I waited and watched her lay her eggs? Now if I let her go she would surely return to the sea. What ailed me? I had the most terrible desire to show all those proud fishermen what I had caught. I would find rope and tie her by one foot. No, she would bite any rope in two. Suddenly I remembered all the small land tortoises I had rescued from their backs. Ah, ha, my beauty! I shall heave you over. And so I did, heaven forgive me."

Once that was done, Bob said, there was no turning back. Peter and Mac and the others treated him like some sort of hero. He basked in approbation. Yet deep inside him was the knowledge that he wanted no part of it.

"You can't imagine what it did to me when you demanded the release of my prize, Sissy. Why, oh why, didn't I listen to your reason and compassion? I still live through the murder of that turtle, the butchering, the horrible effort to partake of its flesh. And you, your eyes dark with tears, gagging on egg and meat."

All I could do was to remain silent and hope that his telling of the tale might exorcise the demon. For me, nothing will ever blot out the memory. Sometimes the feeling I had

then, even the nausea, returns when visitors to the house gaze at the big skull.

"What kind of skull is that?" they ask.

"A sea turtle."

The big holes where the eyes were are wondering still. There were one hundred and ten eggs, one hundred and ten little turtles waiting to be born.

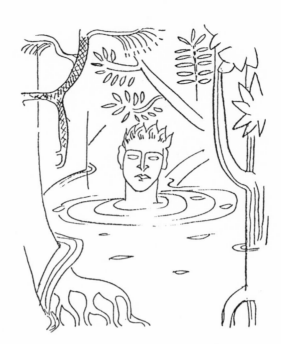

Chapter Five

We had for some time been waking up to Bach's Brandenburg Concertos. Whoever woke up first slipped out of bed and put one on the record player, then slipped back in. That spring we received an invitation from friends to go to the Bach Festival near Baltimore. We could not resist the thought of real, live Bach. Bob decided that we would go up by bus and come back down the Ohio and Mississippi rivers by canoe. The river trip was one he had been eager to share with me.

We stayed in Baltimore with friends, picnicked on the way over to the Bach Festival, and arrived in comfortable time for the B Minor Mass. Bob had a feeling of elation that lasted for days. The community's involvement, which resulted in such a consummate work of art, thrilled him. We stayed through the St. Matthew's Passion the next day and Bob said that, had it not been for the B Minor the day before, it would have been the most wonderful experience of his life. He said his body was in a state of levitation, hovering just

above the hills. We felt that the festival should be included in every year of our lives.

We soon took a bus to Louisville, where we would leave on our trip down the Ohio and Mississippi rivers. We had ordered a lap-strake canoe from a place in Wisconsin, and fifteen minutes after the canoe arrived we were on the riverfront loading up. We slipped into the water just above the locks with my aunt and her son-in-law gazing down at us. My Aunt Angie looked very worried but Cousin Ed was smug; he had furnished us with maps of the Ohio all the way down to Cairo. He didn't realize that Bob had the highly developed instincts of a homing pigeon and needed no maps to tell him if a cutoff was real or make-believe.

We entered the locks and Bob had us out of the main stream and close to shore with a few deft strokes of his paddle. When night came on and we camped, it was eerie to lie under thick trees that came right down to the water, feel dark sky pressing down, and hear the slow gurgle of flowing water.

One night, where the Ohio was dark and narrow, Bob suddenly spoke. "Water is the element of feeling. I've been lying here thinking about it."

"I don't think I know just what you mean," I said.

"I'll show you" was his answer. "We'll take a swim."

Holding me close to his side, he led me to the river. The air was still but the water felt like ice. I hesitated, but straight on through the saplings that stood in the water we moved until the gurgle was right in my ears as I stood neck deep. His voice came, urgent, "You cannot see, you cannot hear, you cannot taste, you cannot smell."

I resisted. I had never liked being forced into or held under water. Inexorably we moved forward. The blackness closed over my head. The current caught and pulled. The water had such substance, such weight, I felt it with every atom of my body. It seemed to have a million small fingers equipped with suction cups like the hands of a rainfrog. I

would never get away from it. The arm about my shoulders never slackened its hold. When we broke the surface, I was beginning to take on water. It sprayed out of my nose in a torrent while I gulped for air. I turned on my back, floating, to get my breath.

The swim back to our camping spot was long and hard. We took advantage of the lee of land where the river curved. I was a stronger swimmer than he in short, easy laps, but his power and endurance were phenomenal. At last he steered us to shore. With our blankets draped around our shoulders, we sat at the base of the biggest tree on our little rise. I was unashamedly exhausted. Bob was filled with the most unaccountable energy, like some violent electrical current. It was even uncomfortable to have my shoulder touching his. He wanted to know exactly what I had felt in the water.

"That's easy," I puffed. "I felt as one must feel when one is drowning." He looked at me incredulously.

"That's not what I want to hear," he cried. "I want to know exactly how the element of water affected your sense of feeling. It's very important."

I didn't want to fail him. I tried to still the beating of my heart, to make my brain function. Tentatively, I stammered, "Well, at first it felt. . . it felt just like me melting into me. Beautiful, until the water went over my nose. Then I just didn't want any more of that feeling." I paused. No response. He was waiting for more. "It's been a very long time since I was a fish," I said. "Both evolutionarily speaking and in the womb."

"Rot," he fairly screamed at me. "Stop thinking! I don't want the contents of your silly mind. Can't you feel at all? Listen, I'll tell you." He shook my shoulder a little before he went on. "Don't you see what it was? It was like finding yourself, your primal self, knowing exactly where you come from. Goddammit, even with you in my arms I am as alone as if I were the only man on earth. Water is the element of feeling.

I become one with all things when I blend water and my sense of touch. No more alone. Everything is accomplished through the senses. Don't you see?"

He did not speak again, but got up and went toward the river, alone. I wrapped myself in my blanket and lay on top of that small hillock on the roots of a tree and shivered the night away, wondering if his wonder was great enough to let him drown. Before dawn I thought I heard him blowing as he left the river; even before confirming his presence, I slept the sleep of exhaustion.

Bob woke me just before sunrise. He seemed refreshed and ready for the day but still distant and self-contained. The weather, which had sparkled on us all the way down the Ohio, began to thicken now. All day it was cloudy and gusty, and when we came out at the Mississippi just before sundown, rain was threatening. Entering the Mississippi was like suddenly shooting out into an ocean. There, at Cairo, the old river looked so wide you could scarcely see the other side. We carried dark, clear Ohio water with us for a little way, but it soon blended into the muddy yellow. High on a cliff under fir trees, we put up the shelter for the first time—the rain beat down—but we were dry. As close as we were, no amount of snuggling thawed him in the least.

The next day the Mississippi flowed mightily forward. The whole country had changed, seemed to have flattened out. The great forests of hardwood trees that had made the banks of the Ohio seem overpoweringly green and beautiful, the steep hills and bluffs, the short curving reaches were behind—back with the locks and dams. The country seemed to consist of fields. The fringe of green along the reaches was willow thicket and alders and the yellow water flowed with a powerful volume. We traveled much faster.

There were islands—islands that seemed like sandbars with bushy willow crowns and willow fringes. We liked to come up on one for siesta time, and we always seemed to find one for night camping. We had not used the tent again,

for we had purchased a large wagon umbrella to protect our camp. It was green and orange, rather hideous shades of both, and tremendous. We also used it for a sail. When we had a following wind, Bob would open it, rest it on the canoe's bow, and give me the handle to hold while he paddled and steered. We raced one day with groups of little boys in skiffs who were doing the same thing with big, thick bushes for sails. We far outdistanced them. Waving and shouting, they watched us leave them far behind and their hearts must have been filled with longing for such a sailing refinement as our green and orange umbrella.

Just above Memphis we ran into strange weather. We had prepared to slip up to a long island for lunch and a siesta. There wasn't enough wind to use the umbrella and the current was sluggish. We were both paddling in rather desultory fashion, without precision or timing, when suddenly a strange soughing wind came rippling across the water. Clouds came tumultuously with it. The sky became dark, the wind moaned, and although we were traveling with the current, both paddling really hard now, it was all we could do to reach a sandy spit at the north end of that island. There were gusts of rain, but we were able to unload and pull up the canoe and turn it over our piled belongings before the worst of the storm came. We took refuge in what must have been a duck-hunter's old blind. It made a snug, dry hiding place from the wind and rain. But the sand, not wet enough to withstand the wind, had stung us like needles as we ran to the shelter.

"Do you know what it feels like?" Bob said, chortling with glee. "It feels exactly like a hurricane." He loved the power and ruthlessness of it, looking at the scudding, low clouds beneath the dark gray ceiling, feeling the dartles of rain and the long gusts of sighing wind. He slipped out of his clothes when the storm was at its height and danced out upon the sand, saying he had to see if the canoe was safe. When he came back cold as a lump of ice, blue with cold,

he came into my arms like a lover at last. We lay there in the duck blind, warmed and in wonderful peace and fulfillment.

We were half-drowsing, half noting the passage of wind and cloud and storm, until the first stars came out that night. The clouds disappeared; the moonlight came. He got out the hatchet, chopped wood from the center of some old posts we found on the sand, and we were able to get a good fire going. Despite the post-storm chill in the air, we swam delightedly in the inside curve of the sandspit just out of the current. Then we had hot soup for supper, a can for each of us. Our larder was depleted, but we would soon be in Memphis, so we ate the last of our Oreo cookies, too.

The next day, still above Memphis, was hot for the first time. The Southern summer seemed to have caught us at last. The sun was extraordinarily bright and there was hardly a breath of breeze. The river seemed as vast as an ocean. We began to encounter catfishermen with their trotlines bobbing gently, slipping slowly downstream. The fishermen kept their skiffs anchored while they smoked, lying back in the skiffs, looking up at the sky in a reflective mood. Occasionally one dipped a dilapidated old felt hat overboard and drank with obvious relish. When the lines had a good head start, they heaved up the anchors and followed.

Our long stay on the sandspit had depleted our water supply and the sun and heat made us very thirsty. Bob dipped his hat in. The water was clear and cold. He tried it, then drank the hat full and dipped one up for me. It was the best water I have ever tasted. He called it a "distillation of America."

Soon we reached Memphis—great Southern river capital. The banks were lined for miles above the city with dwellings—houseboats, camps, shacks, anything in which a person might live, from old buses to boxes. We stopped at the foot of a long paved street leading up to the business district. We had to lift the canoe up and set it on a high stone retaining wall. Bob smiled at me after this feat and said, "Let's

get some ice cream." We had to walk a long way and we each had a ten-cent cone before going to buy our supplies.

As we left Memphis, going under the old Mississippi River bridge, a baby swallow fell out of its nest and landed in the water close to us. Bob paddled like mad, grabbed it, cuddled it and dried it in his hands. I valiantly wielded the paddle, keeping us on course. There was no question of putting it back—the bridge was far too high. He made it a nest in his hat, then handed it to me, saying, "Steve Brodie." The bird was easily christened and for four days we did little else but feed him. What an appetite! He ate berries, bugs, bread—anything we had. He was alert, lively, and demanding. We were heartbroken when he died during the night.

As we came into Greenville one day just before suppertime, the levee was crowded with Negroes fishing. We stopped for ice cream but when we got to the drugstore Bob said he didn't want any. He said it was just a little too chilly for ice cream. As it was 99° just outside the drugstore, I should have been warned. We paddled and drifted on down the river. That night he went to bed without supper as soon as we stopped. We were on the Arkansas side in the middle of a very lonely, swampy reach. The Mississippi side was a long, long way across and looked even more impenetrable and swampy. Before I went to sleep I saw a little light over there for a short time.

Morning brought a white mist and Bob could not walk or move. I felt his head—it almost burned my hand. He was delirious. I don't know how I got the canoe launched, loaded, and him into it, but I did. I began to paddle across to the other side—to where I had seen the light the night before. Sure enough, there was a track leading back into the swamp, and as I came up hounds began to bay. Would they attack me? Not far away I could see smoke rising, so I made fast the canoe and started on the path that widened out. Suddenly I saw a pack of hounds coming towards me. Behind them stood a man. I could tell immediately he was retarded.

He was making queer mouthings and drooling. Just before the dogs reached me, a man on horseback with a bullwhip in his hands rode between us and sent the dogs cringing with one tremendous crack of the whip. "Put 'em in the pen," he yelled to the idiot.

"And what air ye a-doin'?" he asked. I told him how ill my husband was and he told me to go back to the Arkansas side and paddle on down to Lake Village, where I could find a landing and a hospital. It was plain that I was not wanted there and would get no help. I turned and hurried back to the canoe. Bob had not moved. His eyes were wide open, but he did not seem to be conscious. I did the only good paddling of my life on that trip down to Lake Village, and he never knew it. There were men working at the landing who helped get him into an old truck and drove us to the hospital.

A doctor worked over him for hours and diagnosed malaria. Bob was in that Arkansas hospital for five days before he became really conscious. After ten days the doctor released him. Bob looked like a walking skeleton and he had about as much strength. There was no question of going on in the canoe. Bob's father telegraphed money. We had the canoe shipped by freight, then took the bus to Jackson and the train on to Gulfport, where the family met us.

Bob never wanted to talk about that trip. To me it had been a fantastic and beautiful adventure, but something had bothered him from the very beginning. I thought I knew what was wrong. The last time he had covered that territory, he had been at the beginning of a painter's career. How differently things had turned out. Now he was saddled with a wife and a pottery business. Compared to the heights of creative experience, ordinary happiness, I think, can have little appeal. I had grown up in a family in which the creative act was the giving of oneself to others in ordinary human intercourse. I perceived a willingness within myself to give up my own desires and longings for normalcy to nurture his creative nature. The beauty he was able to interpret became the all-

important thing in my life. It was an unusual relationship, filled with bliss and despair. In the end, I was left not with just a memory but with a living synthesis of Bob's relationship with life.

 I became increasingly aware, after the river trip, of underlying forces in Bob that I couldn't understand. They were evidenced at first by little flare-ups, small explosions of unbearable intensity.

I think it was September 29, 1934, Bob's thirty-first birthday, the day of Saint Michael and All Angels. I had scrimped incredibly to save what seemed a huge sum of money to order something I thought would give him great bliss, the *Missa Solemnis*. He was always humming bits and pieces of Beethoven at his work. The package arrived and was hidden deep in the big chest in the bathroom beneath the blankets. The morning came. How lovely the first light touching the reddening rose haws of the Cherokee rose. I lay a moment savoring the sweetness of the day and of his presence beside me, and of the coming surprise. I knew that he was awake. Before I could heed the warning signs, which were literally bristling around me, I leaned over impulsively and gave him a quick kiss.

"Happy Saint Michael's Day!" I burbled. "Oh, how glad I am that you have such a fine birthday."

"God damn Saint Michael" was his response.

Still, my joy in the day was with me. I got out of bed, tore the wrapper from the record, and put it on the phonograph. Ah, Heaven!

Bob appeared. His face had no shine. Like a storm he whirled toward me, his arms enveloping me. We moved with utter solemnity in a somber dance. The end of the dance

came suddenly. He pushed me out of his arms onto the porch. The door banged. Through the window I saw him pacing up and down the room, heard the snort, saw the race to the phonograph, saw the record snatched from the turntable, heard the crash, saw his feet trampling the fragments. Then he was gone.

I could not have believed, during that long day, that I would ever forgive him. I did not shed a single tear. I remember how they burned behind my eyes. Dry-eyed, I began to clean the house; every inch of it was subjected to an intense scrubbing. When I had finished, his mother appeared at the door. "Bobby hasn't been to see me. It's his birthday, you know. Where is he?"

"I don't know," I answered. "He went off early this morning without a word. Oh, Mère, he broke the *Missa* to pieces. He was terribly upset. I just hope he's all right."

"Bobby is Bobby," she said, with just a touch of arrogance, just a hint of "You leave him alone, it's probably your fault," and she was gone.

I went for a walk through town, across Fort Bayou bridge, wondering a little where I was going. Halfway out the highway I started to turn back but something prevented me and soon I was turning off toward Back Bay on an old road he and I had found when we were looking for Indian artifacts. Cutting off the highway through dense myrtle bushes, the road went down through a bog full of frogs, one of his drawing places.

Over the pond, dragonflies and damselflies hung in unusual profusion. Their frail new wings shimmered, drying in the filtered sunlight. There must have been a hatching. I dropped to my knees, looking along the plant stems growing from the water. Sure enough, the awkward, grotesque larvae were still crawling up from the muddy depths, ready to metamorphose. Oh, the things that I would never have known without Bob.

Crumpled there by the muddy pool, I released my tears

at last and wept away all bitterness for the vanished Missa and, perhaps, accepted that Bob was Bob. I got up and followed the trail, an old horse-and-buggy road, three ragged lines through the grass. Presently it meandered through an ancient pecan grove rank with myrtle and wild grass. No one came there anymore. No one harvested the nuts and in some years there were far too many for the wild creatures. Bob and I had been taking our share of them. Looking up to assess the crop, I could see something strange, something blue in the midst of the greens and browns. I was thrashing wildly against the undergrowth now to see. Briers tore at my legs. Branches whipped my face. The blue was high in a far tree, the faded blue of denim. What was he wearing this morning? How long has he been hanging? Oh Lord, will there by any chance. . .? I fell against the tree trunk. He was standing on a high branch, laughing at me.

"How wonderful!" he cried. "I was just wishing for you." Down he came, swinging from branch to branch like any monkey. No preliminaries, he just seized the object of his desire, flinging me on the grass, and that was that.

"You never liked to be surprised by love, did you? Oh, my darling, it's so sweet not to know it's coming, just to be, to be in the moment of bliss." The pause was long. "I'm sorry about the Missa. It would have haunted me for years if I had not known that you are the world's best forgiver. I love you, I love you."

Chapter Six

Fall, with its contrast of brilliance and mist, had slipped into winter. After a long day in the woods we relaxed before a small fire. Bob was reading and I was drying my hair. He was on one of his perennial Chesterton pursuits, very much absorbed. He had, in the old school days, subscribed to Chesterton's paper and rereading these had put him in a religious mood. Chesterton's conversion to Roman Catholicism fascinated him, and time and again throughout his life Bob was within a hairsbreadth of following suit.

Christmas was coming upon us and he was absorbed in the Prince of Peace, the Baby, symbol of love all-conquering.

"Let's do a play for Christmas."

"Wonderful!" was my answer.

Thus we embarked on the great Christmas play that nearly wrecked our marriage and my friendship with Farnum, a Radcliffe friend who came from Florida to spend Christmas with us. Our house was transformed into a theatrical workshop and I was filling so many "assistantships" that I had no time to prepare for my guest. I could be found danc-

ing, writing, painting, cutting out beaverboard costumes and scenery, making musical instruments, and practicing on them.

During this time I encountered one of Bob's more wonderful and disturbing traits. He later affirmed in his writings that, through a process he called "realization," he could become one with tree or insect or any living thing. It was connected with the use he made of his five senses while he was creating paintings, drawings, any kind of art.

This Christmas he became, successively, man emerging from the animal state and evolving through the ages to the time of Christ. In the beginning of this evolution, his whole person changed. One morning he appeared from work bent over, long arms hanging, eyes on the ground, his walk a peculiar slue-footed shuffle. He would not look at me. He whiffled when he took a breath, and he did not speak, but instead grunted and nudged me with his shoulders; this I fortunately interpreted as a desire for food.

He was like an animal, returning to its familiar place to eat. It was early, but I served lunch, a plate for him and one for me. As I sat down he growled threateningly and appropriated both plates, devouring their contents like a dog. Afterwards he lay before the fire and when I came to put a log on it he was gone instantly with a strange, strangled shriek, a ululation of fear. I saw him through the window spraddled on the ground, hugging himself to the earth as though his very life depended on its presence. Had he lost his mind? He shuffled off.

When four o'clock came and he hadn't returned, I went to Mère and asked her if he had ever acted like an animal before. She was quite angry with me. "Don't be ridiculous. He's never had any sort of a spell. He's working on his play. Don't bother him."

At noon the next day he appeared, walking tall and free, humming Cesar Franck's Symphony in D Minor, and consumed with hunger and elation. "I know now how they

were, those earliest of men," he said. "The earth was their god; they were so close to it. It's only when we get far away from our gods that fear devours us. Staying close is a necessity. The elements were man's gods, you see, until the advent of love. I've got it now; it's such a beautiful paradox. Chesterton would have loved it. All this terrific strength and suddenly the Babe, the Son of Mary." He sang it, the old "Greensleeves" melody.

And the Christmas play took form. Earth became a turtle. He told me of a myth from the South Seas in which the turtle emerges from the sea to create the earth. I was full of joy in his paradox. I worked like a slave on the turtle, not realizing I was destined to wear the heavy contraption. Then, to my surprise, he made a second turtle.

"Why two?" I asked.

"Symmetry!" was the reply.

Now he became the discoverer of fire: a creature who desired raw meat, completely contrary to his usual vegetarian tendencies. He rushed madly about, carrying a flaming torch of kindling. At one point he set the woods on fire and the spell was broken by his frantic labors to put out the flames. After that came the cutting out of the flames for the play and painting them, which was exciting.

One morning, lying in bed, he remarked, "Water is first, of course. It seems to be elusive. I think it is the quality of being liquid that is hard to realize. I need to lie in it and be absorbed into it."

Although it was December, he arranged to travel out on a shrimp boat the next day before dawn. He was returned by the fishermen in a sort of catatonic state, and recovered only when I managed to get him into a tub of hot water.

"Nip," he said, "nip, nip," and water took the form of a gorgeous blue crab.

"Air and spirit are one," he told me. "There is a soaring quality to both spirit and intellect. I believe that all attempts to reach great heights in architecture or flight are expressions

of air worship, and that many cultures have sprung from that aspiration. The Greeks had Icarus."

During the next few days I saw him frequently in the high branches of the tallest pines or lying along the spreading branches of a live oak.

"I need a cliff," he said, "a great cliff above the sea."

He borrowed the Ford and once more was gone. His return marked the birth of air. Air was a bird. No ordinary jay or gull, but a swallow-tailed kite. The hapless actors in the play were to curse the day that gave those kites tails. We fell over them; they caught between our legs and tripped us. Airborne, we were not.

He cut two small pines, grumbling about ancient Britons and a feeling of great pain in the region of his navel.

"You can't get sick now, after all this work," I said.

"I'm not sick," he assured me. "In the old days a man who harmed a tree was fastened to it by his navel and driven around it until his skin was peeled off."

Then he required music. "There will be a primitive sound to begin with," he said. "Tom-toms or a drum."

He covered the ends of a lard can with pieces of old inner tubes. "Makeshift," he murmured. He would play the drum and the bamboo flute himself, and he and his brothers would sing. Perhaps his mother would play the piano? She preferred to be in the audience, and was until the end of the production, when she rushed to the piano and became a part of the ultimate revelation.

My poor Farnum arrived on the bus in a state of exhaustion, only to be plunged into the hurly-burly of arduous rehearsals that had to be compressed into two days before Christmas. The costumes were as heavy as lead and no provision had been made for attaching them to us. We were supposed to be able not only to move without losing them but to perform intricate choreographed steps in them. But they were incredibly beautiful costumes.

Christmas Eve came. Our family and a few friends assem-

bled in the living room of the Barn. Framed by the two trees that Bob had cut, the stage was adorned with the costumes representing water, earth, fire, and air (crab, turtle, flames, and bird). The prologue was read. I remember that it began "Well met, my brothers" and proceeded to a sort of confrontation between the elements. Which was stronger? Who shall judge? Man. Each element put on a display designed to win the championship. Then Farnum and I hustled the four elements from the stage and helped each other into the two crab shells. Our arms were thrust into tape brackets fitted to the wrists near the bright red points of the shells. Thus we attempted to hold the crabs to our suffering bodies. Our eyes peered from between the crabs' eyes in a vain attempt to see.

"You don't have to see," grumbled the impresario. "There is only so much room and so many steps." We sidled across the space and back, lifting the claws by means of a string clutched in our teeth. Pausing in what we divined to be the center of the stage, we moved rhythmically away from each other, rejoined, and left the stage. Then earth. We got behind the turtle and lifted him up, entering the arena with tiny steps and pauses.

"Remember the thousands of times you have watched turtle encounters," Bob urged. "It's the slowness that is actually overpowering."

"I swear to God," said Farnum, with a moan, "I've never watched a turtle encounter."

From Bob, disgust and incredulity. "Rise up on your toes. You must know how those little curved legs behave."

Alas, that night the turtle dance was not too different from the sidle of the crabs. Farnum had developed a limp by now, and later was congratulated by Bob for what he termed her "turtle lope."

Fire was easier. The costumes were in two pieces and the effect was achieved by raising and lowering alternate sides. The movement was a bit like rubbing your stomach and patting your head.

Then air!

"Leap!" Bob screamed. "Get off the floor. Soar. Oh, for the love of God, move!"

Those swallowtails did us in every time. If our own feet didn't trip us, Farnum's feet tripped me or mine tripped her. We found it utterly impossible to soar.

The night of the play it didn't matter. There was Christmas Eve magic in the air. Everyone, even Bob, saw what he or she expected to see. The crabs were like fiddlers in courting season; the turtles were slow-moving and powerful; the flames soared and consumed; the birds were borne on the updraft of some auspicious air current. And, in the end, one sudden light in the little back room woke up Pat's and Peter's baby, Michael, in the manger. After one surprised cry, he became fascinated and reached up his arms just as Mère began to play "Oh, Holy Night." The tangible feeling of love expanded and rocked the walls of the Barn. I think that even Farnum forgave me.

Free! Free! Costumes laid aside, we drank mulled wine and welcomed the Holy Child.

Chapter Seven

Bob and I had an arrangement with his cousin Dick McConnell in New Orleans. One year Dick and his wife Virginia came to see us; the next year we went to see them, and the four of us usually went to the Sugar Bowl game in New Orleans.

Bob and Dick were a two-man crusade to save the many varieties of wild Louisiana iris that grew in Gentilly, and we made trips together to dig the wonderful roots in Honey Island Swamp. Each spring Dick dropped us a card reminding us it was time to dig iris and instructing us to meet him in the swamp.

"Dick knows," Bob said. "He always knows exactly when the iris are ready."

We borrowed the ancient khaki-colored Ford, a vintage touring car in which the Anderson family had so often gone "caravanning," as Mère put it. Bob assured me Dick would provide lunch, but the last time I had relied on Dick we dined on muskrat livers at B.F. Leeper's trapping camp in the middle of Honey Island Swamp. I packed a lunch.

Bob drove with his usual abandon, more interested in his surroundings than in roads or other cars. "Dick says this may be the last trip."

"Why on earth would that be?" I asked.

"Dick says," he went on after a skirmish with a shrimp truck, "that New Orleans is moving out this way and he expects all kinds of developments."

Dick was right. Today Gentilly sprawls across most of the beautiful land that was our destination. But this was the spring of 1936 and the whole swamp was filled with the incredible light of willows putting out new green. The swamp maples were flames and the iris were the blue of the very heart of a flame. A flight of bluebirds went across the highway just in front of us. Bob spotted the erratic movement of the red admiral butterfly in the flowers by the roadside, and there were yellow sulfurs everywhere. What a pale sun! Lemon yellow. He cried out his praises for the French impressionists who shared his soaring feelings about light.

We drove quietly off the road and onto a track that led to B.F.'s camp, where we were to meet Dick and Virginia. The blue of Dick's car shone through the young trees around the camp. Twisting and winding, we came at last to the shack.

"Virginia couldn't make it," said Dick. He and B.F. already were pretty happy. There was a jug on the steps. "Kiln's best," they warbled. Nearby Kiln, Mississippi, was the undisputed capital of our state's moonshine whiskey industry.

Dick was a good customer. My heart sank. I began weighing in my mind the lesser of two evils: to stay alone at B.F.'s or to go along with those two celebrating the rites of spring. But Bob had no intention of spoiling this trip by starting out drunk. Not even a swig from the jug passed his lips.

We left in the Ford. Dick sat in the front, directing us through tortuous tracks that crisscrossed the swamp in every direction. We stopped on a small pocket of dry land that was circled by small terra cotta iris. They ranged in color from light, almost cream, through every shade of clay, to a deep

brick red. Bob dug with such care. It was my job to fold them into old feed sacks and label them. I tagged two plants of each shade, one for us and one for Dick, who was reclining on a bank, a little like Ferdinand the Bull. I put the prize roots in our bags.

When we left that place, the trail almost immediately descended into swamp. Soon the smaller purples began to appear and we stopped on the roadbed, which had been reinforced with saplings laid across it in a corduroy pattern. We found at least five varieties of iris.

We had left home at daybreak and Bob was getting hungry. "Hey, *la bas!*" he said to his cousin. "You said you'd bring the food. *Où c'est?*" He and Dick knew an infinite number of Cajun songs and often conversed in the pseudo French they sang.

"Thought we'd eat at B.F.'s," Dick said.

"Shall I try to turn?"

"No, go on to the end of this track," Dick answered.

On and on we wound. We were in farm country. At last we stopped at one of the farms to ask our way. A voluble and exuberant Frenchman came to the door, welcomed us with open arms, and insisted that we come in. "*Voilà!* My birzday is!" he kept insisting. "Ize cream—come—homemade!"

It was cream cheese ice cream, rich and delicious. We had big helpings and listened to accordion music and much talking before we were sent on our way.

Bob and I left Dick at B.F.'s and came home with our bag of marked iris and set them out. We never knew whether those precious roots survived. By the next spring, Bob was in the hospital. By the time we thought of irises again after that, a storm had swept the whole area of our planting out to sea.

Years later, though, when our son Billy built his house on the Point and began clearing out the underbrush, lo! a huge clump of Louisiana blues was revealed in the edge of the marsh. It was a little like a resurrection.

Fall came. As the weeks rolled by, Bob and I both began to have strange spells of violent chills and fever. Our physician finally diagnosed it as undulant fever and traced it to the iris trip and the Frenchman's birthday ice cream. We were cured by time and a series of injections by a physician who came to us from New Orleans to administer his vaccine.

During the worst of our illness we spent a good many days in bed full of aspirin and assorted liquids. Since we were spending no money for food, I had ordered an album of Beethoven's Piano Concerto No. 5 (The Emperor), with Rudolph Serkin and the Berlin Philharmonic. It took quite a while for the album to reach us. When it did, I was elated. I felt healed as I played the record over and over. Bob, on the other hand, seemed to sink deeper into his trancelike state. It was almost more than I could stand to see him lying there with glazed eyes.

One particularly dreary night when the heavens opened up and the rain poured down, a bolt of lightning struck the transformer and the music stopped. Bob leaped from the bed as though charged. I heard him dashing wildly around. He collected paints and a large sheet of paper. Above the sounds of the storm, I heard the Emperor going on without interruption, but it was in the voice of Walter Inglis Anderson. In the dark he was obviously painting while he hummed. Suddenly he was back in bed, shivering violently against me.

"Are you all right?" I whispered.

"Wonderful!" he exulted. "I had a vision. Every note, every chord of that incredible music had its color, its blend. I have it all down. Isn't it strange that I never noticed before? In fact, I laughed at that fellow in Cleveland with his color

organ. Oh, what a revelation! Darling, I love you. I think I'm cured."

Bob was equating music with color and form. The *Emperor* became extravagant sunsets with dark, violet clouds. The Bach Brandenburg Concertos were like mountain peaks or pine trees in golds, icy blues, and greens, scintillating with light.

I wish I could remember more of this musical vocabulary of his. I used to close my eyes and try to see the music as design and color, but I could only see the dark red of blood behind my eyelids and the gold of cracks when the light came through.

"Oh, weird and wonderful one," I chanted to myself, "will I never be able to keep up with you?"

During the miserable period of the undulant fever we did not see the family often and only realized, when we wanly crept forth at last and saw him again, the depths to which Bob's father had sunk. He looked transparent. There was no evading the fact that the end was very near, but Bob refused to believe it. "He always feels the cold so," he said to me. "He'll be fine when the first warm days come." I don't see how he ever stood going to school in Switzerland."

My eyes and voice were full of tears.

"What's the matter with you?" he asked.

"Oh, darling," I said, "surely you must see that he isn't going to get well."

Bob looked at me queerly and, instead of continuing the walk to our house, jerked away and started back toward the waterfront. It was hours before he came back.

Mr. Anderson died toward the end of February 1937. Bob remained wooden throughout his funeral and, as he had after my mother's death, seemed to seek solace in sex. For weeks afterward, the sleepless nights were full of long descriptions of his father and tales of childhood, some of them half-heard because of my own weariness.

Now came a terrible period in Bob's life. It seemed sud-

den and overwhelming to me, but I suppose a doctor or a trained lay person might have realized that it was becoming impossible for him to cope with his life as it was. First, there was no more pleasure for him. Food and wine, which had been joys to both of us, he hardly touched, and then with distaste. We had always had music to get up by, music at meals. Now he said, "Turn off that thing," of the record player.

At first his sex life remained important to him, but he practiced birth control, still maintaining that life was far too horrible to ever think of having children. He no longer sang at work. His mother said he was grieving for his father. I think the truth was that he could not face the routine of making a living, that his whole soul was crying for the pure art he needed to express with his painting. His life was based on someone else's pattern and he could not conform.

I kept thinking that we would wake some morning to find these dark moods a thing of the past, that he would be ready to resume life as it had been. For me, the years had continued to be good. I could not believe that they were not so for him. After days of deepening distress, one morning I heard an agonized cry from the other side of the bathroom door. "Oh, my God!"

I put my shoulder against the door and pushed, falling into the room. He was standing naked at the basin watching the water run out. The water was tinged with pink from a cut that encircled his right wrist. I could see the double-edged razor blade on the floor. He did not give me a chance to speak.

"Who is my God?" he implored. "Is it my father who is dead?" He dropped to all-fours and began rubbing against my legs like a cat. "Is it the cat of your dreams?" Tears streamed down his cheeks. "They say the spiral goes the other way on the other side of the equator. Still it is a spiral." He reached up and grabbed my wrist. I could see that his cuts were not deep.

"My God is a spiral," he shouted, "without beginning or end!" He sat down on the floor and began to pull on his trousers. "Let's see how many gods we can find," he cried.

He pulled me along and it almost felt like one of our old fun excursions except that he was galloping like a horse toward the beach. I thought we were going right into the water, but he stopped. He did not speak. The spirals of waves curled and curled at our feet. He stopped and picked up a conch shell. The twisted end repeated the spiral of the wave.

Going back, we stopped in the thickest of the grape vines. The tendrils curled like springs. Under the pines there were fallen cones. He traced the spiral growth pattern on the stem end. In the slough, he touched the tight coiled ferns; the seeds of the swamp maple spiraled like corkscrews to the earth. He tried to speak to me, but no sound came from his throat, only animal cries, inarticulate and somehow menacing. I sensed a sort of atavistic knowledge teeming in his brain. What was happening? What was my role in the strange things that were happening to us? I could not guess.

After this incident Bob became silent and withdrawn. He claimed that he was impotent, and he spent most of each night walking in the woods. One night, long past midnight but still far from morning, he slipped out of bed. He had been ill for perhaps a week, sorely troubled in mind and spirit. I lay beside him during this time like a watchdog. Now, as soon as the soft little clunk of the screen door's closing sounded, I was after him.

The moon was waning, a little more than half was slipping through the clouds, ragged and dark. I could barely see and was guided, I think, by some sort of sixth sense, some extrasensory perception of his agitation. Anyway, I followed, out the road on the edge of the causeway and down East Beach. Bob was almost running at the water's edge. He turned up Halstead Road and I almost lost him when he cut

off suddenly into the woods. He moved like someone equipped with a bat's radar that permitted him to scan obstacles while staying on a perfect course. I stumbled after him, trying desperately to move like a noiseless Indian stalker.

The moon was getting lower and I thanked God when he came out on the marsh at Heron Bayou. He swam straight across the narrow stream, then paused for a moment or two, lying in the water and looking up. I stayed in the woods, going rapidly along to the highway. When he came out of the marsh, I followed him on the opposite side of the road as he hurried along. It was obvious that he had some kind of appointment and that time was running out for his tryst. He struck out east along the railroad track, walking fast from crosstie to crosstie. I was under the illusion that he did not know of my presence, but suddenly a hand closed on mine and I heard his voice almost in my ear. "Let's go together," he whispered.

"Oh, yes," I said, "I didn't think you wanted me."

Now we fled on down the track. I tried to think of ways to get him home. I tugged at his hand.

"Only to the overpass to wait for the Greyhound," he said, "we haven't come far," and he leaned over and pressed my hand on the track, which was still warm from the passage of the train and vibrating with its movement down the line.

"It will be a fine slap in the nose," he said, referring to the joke we made about my crazy desire to stick out my hand and give some noisy Greyhound a smart rap. He gave a funny little chortle beside me.

In a flash I knew where we were going together. He was about to jump down from the overpass into the path of the bus. I drew back. He had a firm grip on my hand and yanked me along. This was where he had been going each night. He knew exactly when the night bus would come charging down the highway. All my breath was required for his relentless pace. My mind was whirling.

We were pounding along the last straight stretch before

the tracks curved over the long underpass, and far ahead a pair of headlights loomed on the equally straight stretch of highway beyond. We were just on time. Quickly, as we reached the rocky shoulders of the overpass, I pitched head-long down the slope, pulling Bob after me. We lay in the tumbled, gray, broken chips of rocks, hands still clasped. The bus roared through, its swishes echoing in the quiet night. Above the pounding of my heart and the gasping of my breath I could hear him sobbing.

He rolled away from me. Before he got up, he reached a hand to my shoulder. His voice was hoarse. "I'm glad, " he said. Then he set off for home in a sort of fast trot. I came after as best I could. My chest felt tight with effort and I was limping, but I knew something unsaid but sure: he would go home. He was asleep when I got there. In the morning he would not speak. He got out of bed but refused to put on his clothes. He would not touch his food. He ambled about the house on all-fours, sometimes barking, sometimes me-owing, snapping at my legs if I passed. When his mother came in later in the morning, she found him with his teeth clamped in the calf of my leg. She retreated to her house and called the doctor.

Our doctor wanted Bob sent to the Mississippi State Hospital for the mentally ill at Whitfield, near Jackson. We had a friend living in Baltimore who felt that Dr. Adolph Meyer, head of the Phipps Clinic in Johns Hopkins, knew the answers to mental illness and distress, as far as they could then be known. We telephoned and received permission to bring him up. Bob snarled, scratched, and bit when I came near, so his mother, his brothers, and our doctor took him to Baltimore. He was heavily sedated and before he became fully conscious again he was lost in the depths of Phipps Clinic, where he stayed for over a year.

Chapter Eight

At Phipps they began treating Bob with water therapy and tranquilizers. Bulletins from Mère and from the hospital offered no encouragement. He had sunk into a condition bordering on vegetable existence. He did nothing. He never spoke. Mère was not allowed to see him, and finally returned home.

April had passed and May had come when Phipps began sending encouraging reports. A new doctor, Dr. Henry Mead, had been assigned to the case. He was a general practitioner of some years who had come to believe that he needed psychiatric knowledge in order to do an adequate job with modern-day patients. Bob began at last to talk to Dr. Mead.

I had been feeling sick and hopeless, but I now resolved to go to him. When I arrived, Dr. Mead told me that Bob felt the reason for his depression was that he had become impotent. I explained then that I knew beyond the shadow of doubt I was pregnant.

"You must have a rabbit test," said Dr. Mead, "and you must see him and tell him the result. It may cure him." He

paused. "Of course, it may not," he laughed. He was giving me a chance to confess.

"If you are implying that the baby is not his, that's ridiculous," I said. He gave a doubtful shrug. My head spun and I felt sick. I managed to leave the room.

My friend Ellen had taken me in. She was living in a single room, so my first concern was to find another place to stay. I moved into the home of my cousin Grinstead Vaughan and his wife, Ethel. It was Ethel who took me to the doctor. When she found that I was indeed pregnant, she was delighted. But I had sunk into a depression of my own.

She would come into my room at night. "Sissy," she insisted, "having a baby is the most wonderful thing in the world. You must rejoice and be glad!" How could I repay her caring with my sorrow and my fear? There was no way I could tell her or anyone else how I felt. Dr. Mead and Dr. Gutmacher, my obstetrician, were kind. They were not about to be condemnatory, but there was no way in the world that I could persuade either one of them that the baby was my husband's. Impotence could so easily, in a supersensitive man like Bob, result from a wife's infidelity, especially if it were completely unsuspected. It was strange that, ill as he so obviously was, it was Bob's word, unspoken but implied, that was accepted over mine.

And so during part of those months I spent in Baltimore in 1937 I lived with Grinstead and Ethel, letting myself be cared for, stifling my inner turmoil, and going to the hospital daily to see Bob. I had never told him about the baby. He had never spoken to me. Once or twice he had taken my hand, but always these advances had ended in sudden outbursts of anger. Dr. Mead had cautioned me, "If you sense that he doesn't want you there, leave immediately."

The baby was beginning to show, and at last one day Bob noticed. At first he looked incredulous. Then his face seemed to disintegrate. In a flash he was upon me, his hands around my throat. Attendants rushed forward to restrain him, buzz-

ers sounded, nurses came quickly, and I was removed from the ward.

I found myself in Dr. Mead's office. He was quite excited. "That's exactly what we hoped might happen," he crowed. "He's alive again, don't you see! Something has meaning. I think we can safely say that we have a chance now." He looked at me. "Are you all right?" he asked. I burst into tears. How could I be? He sat there, remote, thinking of me, I'm sure, as a silly woman who meant nothing to him except as the element in his patient's life that could mean recovery or disintegration. It took me some time to get myself under control.

"You may have a little trouble talking for a day or so," he said. "He must have had a pretty good grip on your neck."

"Dr. Mead," I said, "I want to tell you something."

"Of course."

"This baby is his baby, whatever he may think." I was very tired. I did not think I could go on.

Just then, Dr. Mead smiled. "I believe you," he said.

After that, Ethel had Dr. Gutmacher put me to bed for a week. At the end of that time Mère sent me the money for a cheap little apartment near the hospital, so that she could come up as soon as she felt better. I found a place over a dry cleaning establishment from which I could walk to Phipps. At first I was horribly lonely in the wretched apartment, but slowly I began to straighten myself out. As for Bob, he was definitely worse. He was being given heavy sedation as well as various therapies to calm him. He broke all the bonds with which they tied him. "He has an uncommon strength," said Dr. Mead. "I don't believe I would like to chance it with you at the present time." So for a time I did not see him.

The next week the staff changed on the ward and a new doctor took over. Dr. Leighton was interested in the things that I could tell him about Bob's life as an artist. One day he told me that he had offered Bob a crayon. "He took it in his hand and felt it and then he gave it back." The following week

61

Bob asked the doctor for a pencil and paper. He was given both and spent a long afternoon making lines on the paper. The next day he asked again. This time the attendants gave him an eight-inch pencil, sharply pointed. In an instant he had swallowed it.

I rushed to the hospital to sign the papers to release him to surgery. The pencil was removed. For some unknown reason, this episode had a beneficial effect. He was still silent, but I resumed my weekly visits. I took him chrysanthemums. At first I hesitated because chrysanthemums had been his father's favorite flowers. His illness had come so swiftly upon the death of his father that I thought there might be some connection. But his eyes lit up each time I came with my arms full of flowers, and they gave me something to hold in front of my rapidly expanding person.

Then one day I came a little late. As the door shut behind me I felt tension in the room. I wished that it were open. Bob was sitting on the floor in one corner. He got up right away and suddenly lunged at the flowers, but lost his balance and fell against me, knocking me to the floor. Then he grabbed a flower and began to eat it. The other patients laughed to see him sitting there on the floor picking flowers and stuffing them in his mouth. I found myself without the strength to do a thing. Presently a couple of attendants came. They took him away and came back to rescue me.

That was my last visit to Bob before the baby came. Mary was born on the eighth of December. She was a fulfillment of all my dreams, but I cried. I cried for almost six months.

When the baby was brought to me the morning after she was born, I was afraid of her. She lay beside me, but I was unable to nurse her. When I tried, the little rootings and gruntings stirred no pleasure in me, only pain. The doctor came, saying that Mary was perfect, the most beautiful little girl he had ever seen. Still I cried, "Just leave me alone."

I was in a ward with thirty other women. We had curtained-off cubicles, and everything that went on was im-

mediately accessible to each of us. Proud fathers and beaming grandparents came and went, but my visitors were two doctors from Phipps, Dr. Mead and Dr. Cameron. They wanted my signature and they wanted it immediately. A new course of treatment was deemed imperative for Bob, who, having made a certain amount of progress, seemed to be slipping back. I asked whether he knew about the baby. Oh, yes, they said, the birth had been announced to him immediately.

"What did he say?" I asked.

Dr. Mead laughed. " 'Her name,' he managed to tell me, 'is Mary. Or her mother's. I'm Joseph.' "

I said nothing. "I have the papers right here," said Dr. Cameron. "I want to read this to you and explain a little of what we propose to do." He stood close beside me and read over the release for the administration of the drug Metrasol. I tried to listen very carefully.

"You feel that this is a good treatment and will be of benefit to him?" I asked.

"Yes," said Dr. Cameron, "but that is not all. We want your consent to come from a reasoned and knowledgeable understanding." My eyes were closed so that they would not see my tears.

Metrasol was an experimental drug, Dr. Cameron said. It was still in its early stage. However, extremely exciting results had been obtained from its short-term use, and long-term patients in state institutions had shown truly remarkable recovery rates. "We find very few cases of bad after effects. But you must remember that an experimental drug is uncertain at best." He paused. "The patient is under complete restraint at the time of administration. Also under sedation. The drug is administered by hypodermic needle into the vein at the temple. It is both painful and extremely unpleasant."

Dr. Cameron explained that the effect was similar to that of any shock treatment. The patient went into convulsions and lost consciousness. When he came to, he was to all in-

tents and purposes normal. This condition had remarkable lasting power, and after the series was completed most patients returned to their families. "We feel that Mr. Anderson is an ideal candidate for the treatment. Dr. Meyer recommends it. It will be necessary for you to sign these papers giving your consent." He handed me a legal-looking form.

I took it. Everything within me said, "Sign it quickly and be rid of it!"

"I cannot sign something of such importance," I said, "without thinking it over very carefully. I would suppose that a finding of such importance must have been written up in one of the medical journals. I would appreciate being able to read such a report. Also, I think the whole thing should be explained to Bob. You see, I have the strongest possible feeling that inside he knows very well what is going on and should have the opportunity to make decisions for himself. I understand that my signature is required."

"I will bring the paper from the *New England Journal of Medicine*," said Dr. Cameron. "May I leave the paper with you? Look at it when you have had a rest."

The next morning Dr. Mead brought the promised journal. The article was a mass of footnotes referring to numerous papers in the psychiatric field. Something quite outside myself made me ask to see five of these articles. Many years later both doctors told me separately that even the great Dr. Meyer had been amazed that I could, with no training, have picked the papers that pinpointed the very crux of the matter: the question of shock treatment by drug or electric current.

Dr. Cameron came in the evening with the papers I had requested. Before giving me the articles, he told me that he had asked Bob his reaction to treatment by shock. Bob had looked at him for a long time before replying, "Life in this state is not life at all. Death is preferable."

I read every word and made up my mind. I signed the

papers. I signed them under conditions of terrible distress. I was exhausted just by the signing of my name. If I had been able to turn my face to the wall, I would have done so, but I could not get off my back and there was no wall.

A few days later it was Christmas Eve. The ward was almost empty. Everyone else had gone home. Mary was the only baby in the nursery. Regulations were relaxed. One of the nurses brought in an evergreen branch decorated with tiny gold safety pins, cotton puffs, and silver bells. She placed a heat lamp underneath so that light suffused it. Putting Mary in my arms, she left us together, pretending some call of duty. I looked into the bright little eyes fascinated by the light and suddenly the little tree was the epitome of all Christmas trees, the baby was *the* baby and I was *the* mother. For the first time, real joy welled up in my heart and I ducked my head to the tiny ear and whispered, "Merry Christmas!"

The hospital sent me home after Christmas, home to the horrible little place above the cleaners. I was terrified at being alone with the baby. I knew that I could take care of her, because the nurses had insisted on it since a few days after her birth, but I was apprehensive. It seemed to me that Mary never stopped nursing and never slept.

Outside, the snow blew about and the cold was too biting to take her out. Inside, the smell of cleaning fluid sickened us both. Once a day the cleaner's little foreign wife came up the stairs to sit with Mary while I dragged myself to Phipps. I never got to see Bob, but they told me that the treatments were succeeding even better than they had hoped. Finally I was called into the august presence of Dr. Adolph Meyer. He had the most extraordinary amount of common sense and sympathy. I was quite enveloped by it.

"You must go home now with your baby," he told me. "Nobody needs you here at this time. I promise you I will send for you the minute we feel that your presence will do any good. We are completely optimistic about your husband.

You will go home. You will not worry. You will restore yourself so that when the time comes for your help you will be ready."

My sister Pat came up to get me. The moment I saw her my depression melted away, my difficulties with the baby vanished. I was restored.

 In July of 1938 we took Bob home. He was terribly uncertain. His books, his pictures, even music seemed to frighten him. He could not work; he could not draw or paint. He wandered in the woods, coming in at increasingly longer intervals. He did not want to take a bath or change his clothes. No one seemed to be able to talk to him. He would not read the letters sent by his doctors. He seemed lost in a pervasive sorrow.

He was living alone in his studio, more or less repudiating both me and the baby. Mary was learning to walk and spent endless hours of intense concentration toddling between the cottage and the Barn, holding to the apron of her nurse, Florence. Gradually, Bob began to watch from a distance and the baby seemed to give him moments of pleasure. I was sure that he was getting better and was about to begin to draw again. I bought a shiny new clipboard and a sheaf of Venus pencils.

In the early spring he came to me in the night. I got up and went to the table to pick up my gifts for him. As I did, I heard the crib shaking. I turned and saw him with a blanket in his hands. He placed it with great care over the baby's head and held it tightly in place.

"Bob!" My heart leaped. "You're smothering her!"

He turned and was on me like an animal. We struggled

66

and somehow I reached the crib and pulled the blanket away and was able to see the baby moving her bunny along her cheek. She was all right.

Then he was on me again. I remember one thought: You must not let him overcome you. He will kill the baby.

My mouth was close to his ear. What would be the right thing to say? I felt the package under my arm. "I have something for you," I whispered. "Come to the light and see."

We moved to the porch where the bed was and where I had rigged a light through the window so that I could read in the night. I pulled the clipboard, the thick pack of paper, and the pencils out of the bag and thrust them into his hands. A growl came out of his throat. He brought the clipboard down on my head with such force that I sank to the bed. I heard the ripping of the paper. It was floating down around me like snow; bits of pencil, like hailstones, came raining down. Then he was upon me. I relented.

After a while I heard him moaning, "Impotent, impotent. . ."

"That was certainly not impotence," I heard myself saying. "In fact, Dr. Meyer says there is nothing wrong with you that you and I can't heal with a little patience and a little care in keeping away tensions. That's why I got the pencils and things. You are bottling up the most important part of you. You are an artist."

"Impotent, impotent. . ." he kept moaning. "There, too, I am impotent." How could he think that?

He was in my arms now, and speaking in a normal way. "Someday you and Dr. Meyer may be right, but now you must take me back to the hospital. Didn't you see? I might have killed that enchanting child, whoever she belongs to."

He had loosened my arms and, rolling away, he disappeared through the screen door.

He reappeared in the early afternoon when Mary and I were both napping. I woke to see him standing beside the bed on the porch. He was looking down at me with an axe

in his hand. The shiny blade rested against his foot. He was watching me with a cunning and calculating look.

"I am going to kill you all," he told me, "you and the baby and the babies to come and the father."

"You'll be killing yourself." I said it low and clear through my sobs. I did not move or make any effort to cry out. As I look back, I wonder what held me there. Was it a belief in him that I had never succeeded in shaking? Was it love? And what made him drop to his knees and lay his head on the pillow and start drinking my tears? What made him rise and move silently out into the sunny afternoon?

I rose on my elbow watching him down the path. My eyes were drawn to the floor where he had knelt, a pool of bright blood.

I found him at the Barn. His mother was washing the cut on his foot. It was unavoidable that we confine him in a hospital again.

Phipps would not take him and recommended the Sheppard Pratt Hospital in Towson, Maryland. He went there protesting violently, but he became a model patient. The hospital was eager to get him any reading material he wanted, and soon he was living in the library pursuing every known book about voyages. He did not write, but the hospital sent reports about his intelligence and drive and control.

I was not surprised to receive word one March day in 1939, six weeks later, that he had pulled a library stack over on his attendant and escaped into a snowstorm. Months slipped by and there was no word of him. He had escaped in his hospital whites, without money. How was it possible for him to vanish so completely? All the missing persons bulletins got no response. It was a bitter spring, and surely he would have to seek shelter. How could he exist without money? I knew him well enough to know that he would never steal. Was he lying dead on some mountainside?

The year slipped into summer. I discovered I was pregnant and desperate worry was in my heart.

Chapter Nine

It was shortly after the family Fourth of July picnic that my sister told me Bob had returned. For about a week she had been missing small items of food from the icebox on the back porch, mostly little dishes of leftover vegetables. Also, the bread and the milk seemed to be going faster than usual.

"What makes you think it's Bob?" I asked.

"I went down to the studio just now and there is a mound covered with a blanket on the old cot there. One foot is sticking out, and I just know it's Bob's foot."

We stood there on the show room steps, staring at each other. What now? For me, there was always the hope "Next time I see him he will be himself again." What would he do now? What would he think of my carrying another child?

I dashed down the road, and by the time I reached the little path to the studio I was tense and frightened. There was the mound, the unmoving foot. When I pushed the door, the hinges squealed. He did not move. Was he alive? I dropped to my knees beside the foot. Suddenly my cheek was against

it and my cheek was wet. I had seen the healed sores, the callouses, the cracked and bleeding heels, evidence of the agonies of the long trek.

"Don't say a word," he begged. "Stay like that just a little that I may feed."

Moments passed. I decided that he had gone back to sleep. I became aware of the stench that came from him. I moved, uncoiling slowly from my knees, thinking: I must get the doctor.

He sat up on the cot. "Why are you leaving me? Are you a vision? Have I conjured you up in my dreams? Ah, no. If that were so, you would never leave."

"Bob," I cried, "you are home."

"I knew Pat had found me," he said.

"But why didn't you come for help? You are in terrible shape. You need a doctor."

"And another and another, on and on through the beautiful years. And I need a breakfast and a breakfast and a lunch and a lunch. I need a supper and a supper, too. And I need sleep without fear and rest without interruption. The road has been long."

Within a week his strength had returned. Hot baths with soda helped clear and heal and slough away his abused skin. Hair was washed and trimmed. He shaved off the flowing beard, sideburns, mustache.

It seemed that the trip had purged some devil in him. The baby went to stay for a while with my sister. He and I had long days to ourselves. He talked about things that had happened to him. "This coat," he told me, "has saved my life, not once but over and over again." He took the coat with a caressing touch and reached his hand deep into the huge patch pockets, first on one side, then on the other. Out came a series of small squares, pieces of brown paper.

"This is the log of the trip," he said, riffling through the papers. "Brown paper bags. Sometimes I would find them; sometimes someone would give me food in one." He

70

smiled. "This coat can keep anything." He was showing me a drawing on the paper bag. He stood at the door of a house, wearing the coat. A rather doubtful black woman was looking at his hand stretched out in supplication. "See how well bags take the pencil?" he said.

We sat on the back steps watching the coat flapping on the line. He had scrubbed it with the broom and the garden hose. Wet, it was greener than ever.

"It was bitter cold when I left, you know. I had absolutely no protection for I was dressed in hospital whites, pajamalike things. I was a couple of days through the woods, not daring to stop anywhere. Only brush and leaves to warm me. I learned to make a shelter like a rabbit. One late evening I came to a house along the tracks. An old black woman was bringing some things in off a line. She saw me before I could slip away. I went right up to her and told her I was cold. 'I guess you is, white boy,' she said. 'My old man got dis coat from de Gen'l's wife. Ain't nobody ever gwine use it. Here, cover yosef an' git outen here.' I did exactly what she said.

"It was the colored people who saved my life," he said. "There was no fear, no doubt about what they should do; never any question about turning me in. It was just 'Here's a man in trouble. Do what you can to help.' Trouble for them goes so deep, has been so intimately experienced."

He had said nothing of the second child. It was within four months of delivery and growing fast.

Billy was born in October of 1939. Bob had returned home remembering the early days of our marriage. He expected things to be the same. Instead, now the house was full of babies, the devoted wife preoccupied with children; there was literally no place for him, no place

for his work. He still did not accept either child as his own. He had no reason for this belief except for his delusion of impotence at the time of their conception.

Evenings found me weary, but not too weary to stoke the fire so that coals would still be glowing when I rose for the two o'clock feeding. I could restoke at that time and be warm in the early morning, but Bob stayed up late, burned up all the wood, and never remembered to stoke or bank the fire. The baby and I shivered by the cold ashes. Perhaps it was my annoyance, which I was unable to control, that affected him.

It was one of those cold early mornings. Billy was approaching his third week. I struggled up to light the old stove, but discovered that Bob had used up the stove wood. I put the baby back in his bassinet and went out the kitchen door to find wood. Scrabbling for kindling scraps on the ground, picking up bits that might burn, I felt my fury mounting. I went back into the kitchen with both hands full and an armload of scraps. I did not even notice that Bob was standing by the door into the house, or that the baby lay in his arms. I reached behind with one foot and banged the door shut.

"There you go," he said. He spoke very quietly with a sort of veiled venom. "I'd think you'd let us sleep even if you don't need to."

I dropped my wood into the stove's firebox and turned on him. "Don't you ever think of anyone but yourself? Awake all night, using up all the wood, and wanting to sleep all day. What on earth do you do that's worth anything?"

He suddenly flung the baby toward me, standing in front of the iron stove where the fire was beginning to roar. I caught the small blanketed bundle and held it close. The baby's arms thrust up into the air with the fright of flight and, catching his breath, he wailed a long cry and began to scream.

"You better keep your bastard quiet," Bob said. He was coming closer. The big butcher knife had been left on the

kitchen counter. We saw it at the same time. His hand got there first.

"Bob, no. Please!" I backed toward the door. He flung the knife toward us. It grazed my neck just under the left ear. I turned to see it stuck halfway up the blade in the wall behind me, vibrating in the air like a note of music.

Suddenly Bob was kneeling against me, his arms clasped around my knees. I think they would have buckled without him, such terror swept over me.

"I have to go," he groaned, "I have to go. It's so far, it's too far. I don't think I will ever be able to make it again. You don't know what it's like in the hospital. A time comes when I know without a shadow of doubt that I must leave, or never leave. I know that I don't belong in a hospital. I know it. I need to work, to paint, but I know I have to have help."

The house was so quiet. The knife was still stuck in the wall. I was shivering.

He began again. "Do you think I could go to the state hospital at Whitfield? Dr. Meyer and I talked about it. He thought that if I could get things straightened out in my life I might live as an outpatient for a while."

And so it was arranged. About noon Dr. Frank, our doctor, called to say that he would drive Bob and me up to the hospital in Jackson as soon as we could be ready. As I turned from the telephone, Bob said, "I'm ready." We were on the way within the hour. Dr. Frank gave Bob a sedative. He was sound asleep, sprawled with his head in my lap, before we reached the highway north.

We got to Whitfield in the late afternoon. Sunlight slanted across the lawns and flower beds, across the patients sitting lifelessly on benches. The flower beds were brilliant with salvia, cockscomb, and marigolds. Bob's drowsy eyes lit up at the color. He signed himself in in no time at all.

From the desk where I was making a deposit, I saw him walking backwards down the corridor, waving at me. I re-

member thinking: How strange, he doesn't know that I am dead. Dr. Frank took my arm. "You are worn out," he said as he led me over to the door of the ladies' room. "Give your face a good wash. I'll meet you at the car."

When I reached the car I heard Dr. Frank say, "Are you all right? Put your head back and rest. We'll get something to eat in Jackson."

The road was two-lane and narrow. Dr. Frank was taking the curves on two wheels. How nice! I thought. I was wanting death with a strange, violent, and exclusive desire. I even smiled a little, and then I leaned forward and opened the door. The wind, the centrifugal force, pulled me up and out. I flew like a big bird. I don't remember landing at all.

When Dr. Frank got back to me, I was lying quietly cradled in the kudzu vines that lined the highway. "I'm all right," I told him. "The kudzu caught me. Please don't ever tell anyone what I did. I promise I'll never do it again. I thought I had died already. It just did not seem possible to go on."

He put his arm behind my back. I sat up.

"God says when it is time to stop going on." He said it very quietly and without blame.

I visited Bob at Whitfield only once. He refused to see me again after our initial meeting, so I returned home. A few days later he escaped and vanished into the blue. He had climbed down from his third-floor window on sheets. The morning after the escape, the entire hospital gathered around his building to gaze up at the outer walls. He had delighted many of his fellow patients by ornamenting the walls, from his window to the ground, with great birds in flight, done in Ivory soap.

He was picked up and returned, but he was so sensible, so convincing, that he persuaded the doctors he did not need to be in a hospital. They agreed to accept him as an outpatient if he lived in Jackson. I was at home with the babies. His mother stepped in. She rented a little house in Jackson and took him there to live. A male nurse from the hospital lived

74

with them and accompanied Bob on his trips back and forth to Whitfield.

Friends rallied around. Marie Hull, Mississippi's great painter, Bob's friend and admirer, saw to it that he went to work. He drew and painted, and the doctors at Whitfield eventually released him. Mère at last brought him home.

The doctors said that Bob must be protected from divisive pressures. I began to try to work out those things that seemed to be divisive pressures. I wrote to the doctors for advice, but the advice always seemed to be, "From what you say, you are doing as well as could be expected."

Bob became less and less a family member. More and more solitary, he was like one of those ancient herons who scorn the communal aviary yet come to perch occasionally for respite after the storm. He was lean and strong, as he was to remain the rest of his life, but he was painting very little. He built a tree house and for a while lived in it. The tree house was up the tall, straight trunk of a pine—perhaps 80 to 100 feet without a branch. Bob nailed old pieces of plank at intervals up the tree, and when he reached the haven of the branches he built a small platform.

One day he came to the cottage and put his arms around me. "Come back," he whispered hoarsely, "come back, I won't hurt you. I love you. Come see my house."

When we reached the foot of the tree, I looked up and cried, "It's an eagle's nest!" "And I am the eagle and you are my love. . ." Walt Whitman's marvelous lines came spouting from him. "Come, come."

I am terrified of heights but somehow he had me climbing that tree. He came right behind me. So attuned was Bob to the heights that I got the impression he could become a bird. He

made love like an eagle up there, swooping and gyrating. I think he carried me down over one shoulder, but of course we may have flown.

Afterwards, I knew suddenly that I could not go on living that way. I dashed to the cottage, gathered up the babies' things and mine. By that evening I had rented a tiny apartment in Biloxi. But Bob soon found us, and within a short time I left for Chicago to visit my mother's only brother, Ted, and his wife, Hulda.

Uncle Ted had always cared for me. Now, in Chicago, he tried to persuade me that there was nothing left for me but divorce and a new start, far from Ocean Springs. "Going into teaching, as I suppose you will do eventually, would be hard with these babies. We will set you up in Miami, perhaps in a small gift shop. We know of a very good place," he told me. In a sort of stupor, I found myself going around choosing goods to sell in the imaginary shop.

Without warning one day Aunt Hulda ushered Bob into my room where I was resting. I was startled, but, oh, what a feeling of belonging swept over me when I saw him. He vanished into the bathroom and I heard the water running in the tub. The door opened, he dashed across the floor, picked me up, dashed back, and dropped me in the tub—of cold water.

"Wake up!" he shouted. "For God's sake, wake up before it's too late."

I struggled and at last he let me out of that cold Lake Michigan water. After I was dressed again, we were sitting on the edge of the bed. "I had to talk to you," he told me, "you must understand. No matter what happens, there is a trust that must be recognized. You and I belong together. We are one in a rare and special way. You have to wake up and see it. It's impossible to separate us. I am not sick any more. I promise to behave. Promise that you will come home. Promise!"

"Bob, you're right, of course. . ." Before I could finish my sentence, he was gone.

I stayed at Uncle Ted and Aunt Hulda's house, an island of peace and sanity, for another month, thinking about my future. In all the ferment of my anxiety and doubt, I knew that I must set my own house in order; it meant facing the plight of my father. He was renting a small cottage in Ocean Springs where he had been cared for by two men ever since my mother's death. My sister and I felt that he did not need hospitalization. His arteriosclerosis had left him vague at times, very gentle, quiet, with few ambitions or desires. One of the men who nursed him had just died.

I thought of Oldfields, completely furnished, ready for occupancy. It had separate servants' quarters with kitchen and bath, and there were two baths in the big house. My father had sufficient income for us all to live there. I could care for him there with the help of Robert Andrews, the black man who was one of his attendants.

I made up my mind to move to Oldfields. When I returned to Ocean Springs to carry out my plan, Bob began wooing me again. "Will you go on a trip with me?" he asked.

"Of course," I answered.

"You're not afraid?"

"No."

I felt the trip was essential to his recovery and his future. We both began to work toward it. He got his brother Mac to take him boat hunting. They found a small Penguin Class sailboat complete with sails and oars. He was as pleased as a child with a long-coveted toy.

Mac returned without him, stopping in front of the cottage to call out, "He's sailing home on Back Bay. We found a beauty."

All day Mary and I watched. Back and forth to the beach we ran. Sometimes we pushed Billy along in the stroller. We looked down the bay to the distant bridge, hoping for the sight of a sail. Finally, against the crimson sun, we saw the sail—a fleck of white like a shed feather. Mary sang out, "Daddy, Daddy's coming! See, Mama, see, a big white bird in the sun."

He came fast in the fading light, tearing along before the strong westerly breeze, and we were there on the beach to greet him, the returning sailor. I told him about Mary and the big white bird and he was delighted and promptly christened the boat with a handful of water. "Dos," he said, "I christen thee Dos."

"That means 'duck' in Spanish," he told Mary, "my little white duck with the rounded bottom."

He was ready to leave that night, but I had to make arrangements for the babies and we left the next afternoon. I remember the pearly looking sky of that distant day and how the waves sounded against the planks of the Dos. We started out both sitting on the center seat, each with an oar, and we sculled off in style over the water of Biloxi Bay. The old magic began to work, and peace and a oneness descended upon us.

We went ashore just beyond Marsh Point. High on the beach we gathered dry driftwood and had a small fire. Sparks leaped high.

"Do you remember?" He asked it so softly, but I knew at once the rest of his question.

"That fire long ago," I said, "on this same beach. We were not even married."

"Yes," he went on. "A moth flew into the fire and you wrote a poem about it and the cinder in your eye." He took me in his arms. "Nothing has changed," he said. "I love you."

When we got back into the boat it was late. A half-gone moon gave plenty of light.

"The wind is coming up," he announced. "It's from the

north, a little east of north. We'll sail down to Oldfields for the night."

I collapsed on the slatted floorboards beside the centerboard casing. My head was on his feet and one arm wound around his ankles. The little boat was sailing like a dream. He woke me when we reached Oldfields. The moon was almost gone. We tied the *Dos* to a pier post and waded in and went to sleep on the front gallery. When I woke again I heard a rooster crowing and knew the dawn was beginning. I woke him and we left almost at once.

Just as the sun rose, the wind shifted south and we were skimming up past the creosote works and the L&N bridge to the first reach of the west fork of the Pascagoula River. The marsh enclosed us. It was a uniform and undulating gold, punctuated by small islands of wax myrtle, ornamented by clusters of wild spider lilies.

Bob pulled down the brim of his old felt hat and retired into himself. We kept on sailing until we were so far up the river that the front breeze had deserted us. The sun became hot. The air was very still. Sometimes a bird shot out of the wild rice thickets. There was no sound except an occasional splash in the water. I wondered what he was feeling.

We stopped for a rest on a marsh island, then we pushed off immediately. No word was spoken. The oars were handed over. He curled up in the stern for a nap; I rowed. He slept on through the afternoon. The sun was low when he began to uncurl.

"I'll row now," he said. Nothing more.

"Bob, I'm starving."

He handed me a slice of bread and a handful of raisins.

The little winds walking upon the water were becoming more frequent, more steady. He put up the sail and we tacked up the river, side to side, achieving hard-won yards on each tack. Still, he was silent.

"What is the matter?" I finally asked.

"Oh, my love. . ." It was like a sob bursting out of him. "It's not you. It's all inside. Will I ever get well? It is I who must ask what is the matter and ask it forever." Then we were lying in the bottom of the boat. The *Dos* sailed on, bumping against the marshy bank. He said, at last, "When we get there I'll draw and paint and then I'll be alive again."

The sunset came and it was very beautiful. The shadows were like prairie shadows so long across the golden grass. We began to hear night sounds. First, there were frogs, then a whippoorwill's lonesome wail, a chuck-will's-widow, and suddenly, out of the almost dark, the roar of a bull alligator.

"Now I know we're almost there," he said. A small live oak, horizontal over the water, marking Heart Island, appeared out of the gloom. It was not yet full dark. I could see enough to gather wood for a fire. He cleared a circle where others had done the same through the years. We were soon eating a hot supper of baked beans, and sleep came almost immediately.

With the first misty emanation of morning from the surface of the river, I was awake. He was already gone. His clock was set for earlier timing.

I felt free to go exploring the interior of the little island. Opposite the river side, the marsh stretched for miles. It was just beginning to turn green with spring. Close in at the edge of the marsh, pale Mississippi iris bloomed. A clump of horse chestnut had opened its red flowers, inviting the humming-birds. Turning to the north, I decided to see what lay beyond the thicket of myrtle bushes. I was surprised to find a fairly well-trodden path. What on earth would make such a path in such a place? I started down it parting the shrubs with my hands. In a few moments Bob appeared behind me, a stout stick in his hand. I laughed.

"What kind of dragon do you expect to meet on this tiny island?" I asked.

"You'll see," he answered. We came out of the thicket just at the edge of the marsh. Directly in front of us was a great

loosely knit structure like a nest. I recognized it immediately and jumped back. It was an alligator nest.

"Don't you want to see the eggs?" he asked.

"No," I shouted. "All I want to do is get out of here." He blocked my path. I began to cry. His face went hard and expressionless.

"Because I have been ill," he said, "you do not trust me. What shall we do?"

"We are going to get away from this alligator nest," I screamed. I tried to get by him, but still he wouldn't move. I glanced behind and saw the marsh grass waving. She was coming fast, a furious mother alligator rushing to protect her eggs. I literally rushed Bob, ran at him like a wild creature, pushed him away, and attained the path beyond. I was running all-out. He was not only startled and angry, but left off-balance in a tangle of myrtles to face the charge. He recovered enough to turn on the alligator with the oar in hand.

She gave a horrible bellow. He lowered the oar to meet her charge and it snapped like a matchstick in her powerful jaws. He ran. The enraged mother followed until he was out of her sight. Meanwhile, I had started back with shame for my cowardice and worry for him. In his headlong flight he almost ran into me on the narrow path. We fell into each other's arms, shrieking with laughter.

"You were afraid of her and you were right," he said.

I said, "And you thought it was you I was afraid of."

Hand in hand we went back to the campsite. I told him the things that still bothered me about his recovery; he told me things that bothered him about life with two babies, and we promised each other that we would work together to make our life happy once more.

Back home, neither of us could sustain our resolve. Bob again became like a stranger, a visitor in the house. Gradually, I made preparations to move to Oldfields. Bob seemed unaware, busy with his block prints and his painting. He seemed happy.

In July of 1940 everything was ready. I found a good older woman to live at Oldfields and cook. Her son, about sixteen, was old enough to be a house and yard boy. The farmer who lived in the tenant house there was a friend of many years' standing. Robert would help with Daddy.

I bought a secondhand black Ford and told Bob, "I'm going to Oldfields to live. I've bought a car and a cow. I'm going back to the land. Would you like to come?"

For a moment he glowed. Then doubt shadowed his face. "With your father?" he asked.

"Yes, I'm going to take care of him."

"No," he said. "I won't come."

I left then for Gautier and Oldfields.

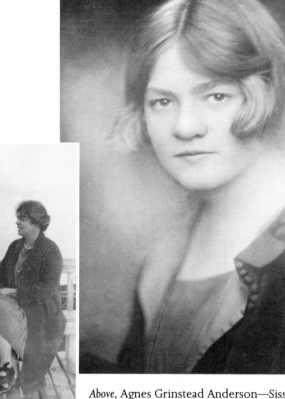

Above, Agnes Grinstead Anderson—Sissy—in Paris, 1926; left, Marjorie and William Wade Grinstead, Sissy's mother and father, on the pier at Oldfields, 1923

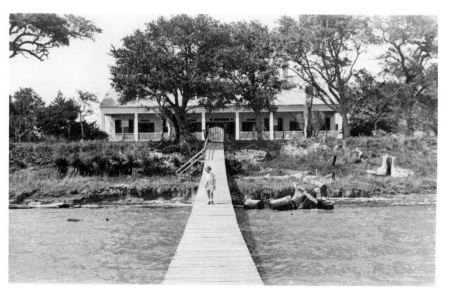

Oldfields, Gautier, Mississippi, 1925

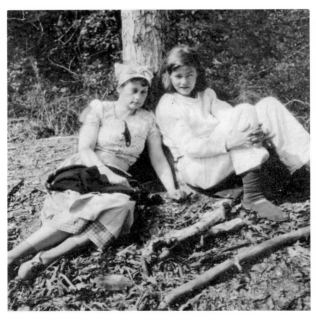

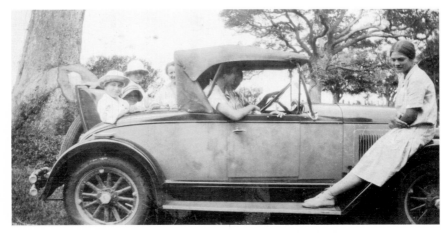

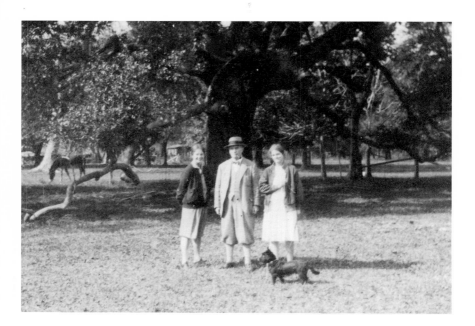

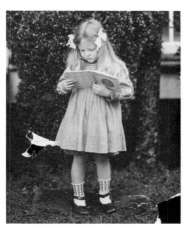

Facing page: *above*, Marjorie Grinstead, with daughters Pat and Sissy, Martha's Vineyard, 1920; *center*, Sissy (right) and Ellen Wassall, 1925; *below*, Sissy on the fender of her convertible filled with Hellmuth cousins, 1931. *This page: above*, William Wade Grinstead with Pat, Sissy, and dog, Timmy, 1928; *left*, Sissy, Oldfields, 1913; *below*, Sissy (holding cigarette) with friend, Katherine Hamill, 1930.

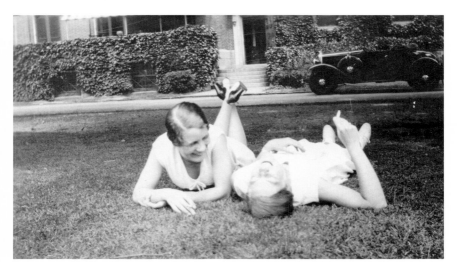

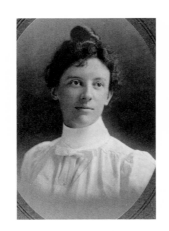
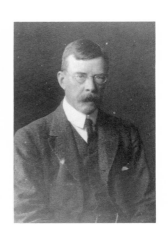

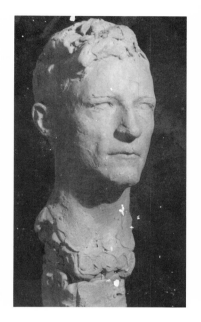

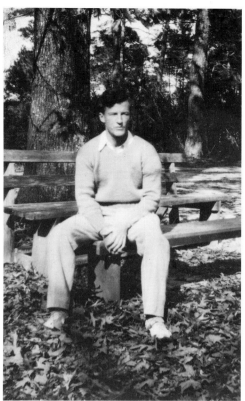

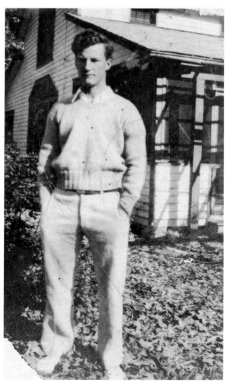

Facing page: center, Walter Inglis Anderson,—Bob,—in 1906; above, left, Bob's mother, Annette McConnell Anderson, 1900; above, right, Bob's father, George Walter Anderson, 1900; below, Peter, Bob, and Mac on the steps of the Shearwater showroom, 1934. This page: above left, portrait bust of Bob by a fellow student, Pennsylvania Academy of the Fine Arts, ca. 1925; above, right, Bob in sweater knitted for him by Sissy, 1930; left, Bob in front of the converted barn at Shearwater, where he lived with his parents, 1930.

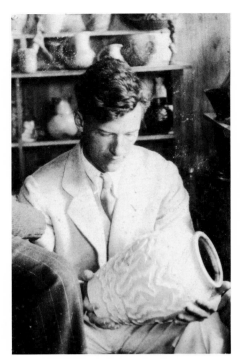

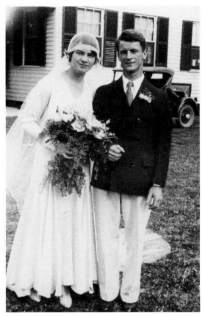

Left, Bob with one of his carved pots, Shearwater, 1934; *below, right,* Pat and Peter on their wedding day, Oldfields, 1930; *below, left,* Pat and Peter's children, Patricia and Michael, 1933; *bottom,* Caroline Gilchrist, Sissy, and Pat, 1929

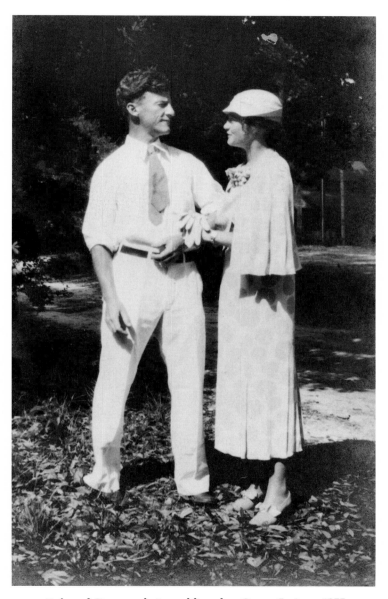

Bob and Sissy on their wedding day, Ocean Springs, 1933

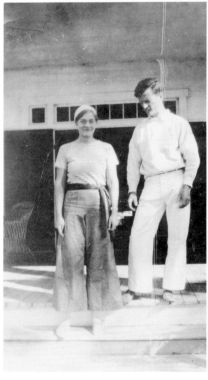

Facing page: top, left, Sissy and Billy, 1939; top, right, Billy and Mary at Oldfields, 1942; below, Sissy and Bob courting at Oldfields, 1939. This page: left, Sissy, Mary, and Johnny on the porch of Oldfields, 1948; below, the four Anderson children—Johnny and Leif (seated), Billy and Mary (standing)

Sissy through three decades as a schoolteacher

Mary, age 10

Billy, age 8

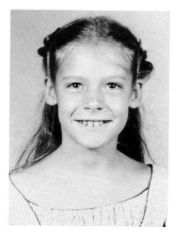 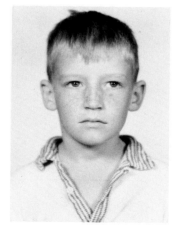

Leif, age 10

Johnny, age 7

Right, Bob at work on the Ocean Springs Community Center murals, 1951; *below*, Harris and Mary Stone Brister, Gautier, 1947; Oldfields after the 1947 Hurricane (photograph courtesy of Mary Stone Brister)

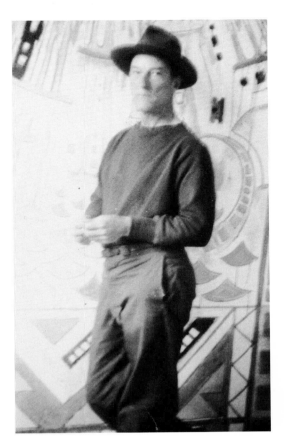

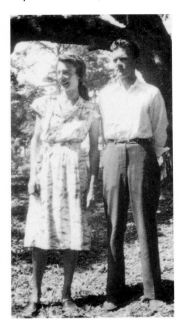

Facing page: above, Bob with Norman Cameron, Ellen Mead's house, Ocean Springs, ca. 1960; *center,* Bob, Christmas, 1955; *below,* Bob at a family Christmas, Peter's house, Shearwater, 1955. *This page, left,* Bob's passport, stamped Hong Kong, 1949; *below,* Bob returning from Horn Island, ca. 1960 (photograph courtesy of Linda and Kent Gandy)

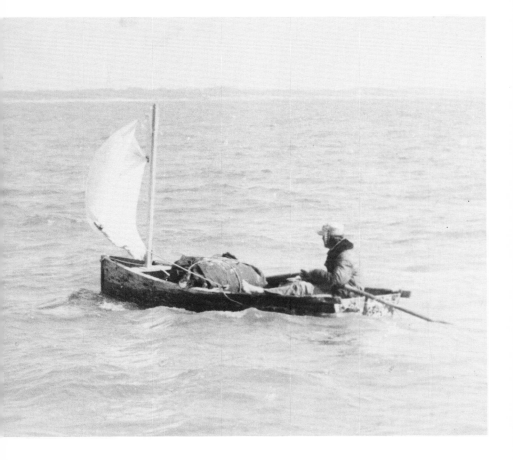

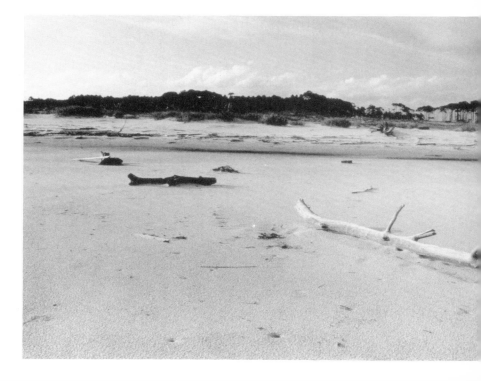

Facing page: top above, Sissy on Horn Island 1979; *center,* Sissy and Leif on Horn Island, 1982; *below,* Horn Island *(photo-graph by Donald Bradburn).* This page: *above,* Sissy, 1987

Sissy and granddaughter, Moira, looking at Bob's sketchbook, 1966

Chapter Ten

The Oldfields years, as I think of them now, stretched from 1940 to 1948. A few months after we arrived, Bob joined us. The house was one of the few remaining pre–Civil War big houses on the Mississippi coast. A West Indies–style plantation house, it sat on a bluff above the Mississippi Sound and was shaded by century-old oaks. From every spot in the house the view was of sea or thick woods. Bob considered it one of the most beautiful spots in the world.

During those years he came back to the human race from that far-off journey of his as much as he was ever to do. Light and happiness entered our lives again. For me, the worst facet of those years was the hostilities that continued between Bob and my father, sometimes veiled, sometimes explosive. And for four of those years, there was the specter of World War II. In his logs Bob often spoke of a day as "halcyon." Perhaps, despite the war and the tensions, those years at Oldfields were halcyon years for both of us.

Bob loved the farming and the gardening. He had never

before lived in the country, never near a farm. Suddenly he found himself observing the seasonal changes, ecstatic at the strange brightening of the world and its creatures in the spring. He began to draw and paint in a sort of ecstasy.

The barn fascinated him, especially at feeding time. He could be found, block in hand, perched in some out-of-the-way place looking, listening, and, always, drawing.

I remember how annoyed I would be when no one could find him. "I went to sleep in the hay," he would say.

So simple, so delightful. Why could I not remember from my childhood the delights of the loft? Was there any reason for alarm? For indignation? What horrible habits of anxiety we allow ourselves to develop. To what good? We never understand, at the time, what other people are seeking.

I know now that the alienated must seek forever the means of reentry into the world of man. Bob was seeking, for some reason, through the simpler world of animals. "Dogs, cats, birds are holes in heaven through which man may pass," he said.

The house at Oldfields had high ceilings with white plastered walls. Bob's eyes lit up whenever he contemplated the murals that could adorn those walls. Ideas raced in his head. Daddy was adamant, declaring, "That crazy artist will never pollute the Oldfields walls!"

Bob solved the problem with very large sheets of charcoal paper, taped or tacked to the walls. There was first a farm mural. The Oldfields barn was a central motif, but the animals were featured. Again and again appeared our horse Jim. Jim, who was small and scruffy and who consented to his various tasks without enthusiasm, sprouted wings of thunder and hoofs of lightning in the mural. His mane became waves of the sea. Of course Jim retained, as well, the humility of his day-to-day chores of drawing the plow and the wagon on his appointed rounds. The cows became subjects of surprising beauty. Turkeys, chickens, ducks, and pigs fitted themselves into the design in miracles of shape and color. Corn, water-

melons, tomatoes, potatoes, and beans appeared in their seasons. People in attitudes of grace performed their functions: carried feed pails, held reins, wielded hoes, rakes, pitchforks. Even the pecan grove appeared, in its bare and misty winter state.

One spring, Bob did a mural of cutover land, land that was a strange, new creation. The great yellow pines had lived there for years untold, exuding a dry, rather bitter air, their carpet of needles discouraging most other plant life. Only the bitter, low gallberry bushes came up through them. The lumber companies had come through, making a clean sweep of the timber. Suddenly in the spring the decimated land became prolific and spongy, filled with creatures to match.

"I don't pretend to understand how this happened. It must have something to do with new drainage patterns," he said.

The land was awash and full of the castles of crayfish, rising ball after ball from the gray earth. There were sundews, orchids, pitcher plants, all manner of frondy, ferny things, mosses, buttons, daisies. Small lizards, frogs, and turtles flourished. An infinite variety of insect and spider life took over. After grass appeared, tender and fresh, free-grazing sheep and cattle came. Only the deformed and stunted pines, rejected by the timber companies, stood forlorn in those meadows.

What a beautiful and moving mural Bob made of it all. The children and their friends were enchanted, so he translated it into a puppet play. He presented it in the attic, with an intricate arrangement of ropes and pulleys so that he could perform the whole thing himself. I remember the sun

rising, with dramatic pauses, and the worshipping dances of the flora and the fauna. I remember the children's shrieks of delight at the ludicrous leaping of the frogs and the slow lumbering of the turtles, the dreadful tension engendered by the many pursuits, which centered upon the patterned moths.

By request, he put it on again and again, with chants and fluting and drumming of his own devising.

They had everything, those attic performances, and if they left the impresario hot, sweaty, and exhausted, the bay was just over the bluff, holding out refreshment and all the glories of a summer night. It was all that anyone could ask of enchantment.

 There were four large bedrooms at Oldfields. My father occupied one, Bob had one, I had one, and the children had one. All had large fireplaces. Bob's room was a very large room with door and window opening on the long front gallery looking out to sea. After we obtained electricity, it was furnished by a lamp, sitting on the floor; a record player and a stack of records, also sitting on the floor; a carved wooden box that held his paints, pencils, and so forth; and a mile-high stack of typewriter paper. The mantel was usually full of matches, cigarettes, and "curiosities"—shells, arrowheads, plants, flowers, fruits, vegetables, feathers, bugs (alive and dead), and bones.

The attic was full of beds, but Bob did not allow one to be brought down for his room. He would sneer at the suggestion and announce that when he wanted to sleep he would come to the big double bed in my room. Seldom did he do this. Even less frequently did he sleep.

Early morning found him out prowling, looking, sorting,

choosing. An entry in a log, as he called his journals, reads: "I watched the pumpkin or squash flowers open—used this for the day's calendar."

What remains of those daily calendar drawings, the execution of which must have been a morning ritual, is a random stack of sheets of paper with a design in ink beautifully worked out like a Persian miniature and painted in watercolor as clear, fresh, and sparkling as a French primitive.

The time he gave each day to creating work to be sold was probably never less than eight hours. He did pottery figures and later linoleum-block designs for what he called "overmantels," part of his continuing effort to furnish people with good art at reasonable prices to use in their homes.

In spring and summer the garden took attention, and in winter he gathered wood for the fireplaces. He spent some time each day listening to music, often dancing vigorously. He might sleep a few hours, rolled up in a blanket before the fire in winter or on the end of the pier in summer.

Day after day I expected him to collapse into bed at nightfall; night after night, after the evening meal, he drew the lamp close at the dining room table, spread out a book, seized his drawing block, pen, and India ink. He had taught himself a very adequate Spanish, mostly for the purpose of reading Don Quixote. He had heard somewhere that Cervantes's birthday was September 29, the same as his own. The kinship he felt with him led to more than a thousand pen-and-ink drawings and a series of crayon sketches of the good Don. Another purpose in his learning Spanish was to translate the four volumes which he had of Summa Artis.

Far into each night he read and illustrated, virtually translating literature into line drawings: Dante's Divine Comedy, Milton's Paradise Lost, the Iliad and the Odyssey, Darwin's Voyage of the Beagle, Ariosto's Orlando Furioso, Alice's Adventures in Wonderland, and many others. He read Hemingway's For Whom the Bell Tolls with great joy and found Homer just as stimulating. Perhaps because of his own ex-

periences in the dark recesses of the mind during his illness, he had a particular curiosity about states of mind. Through his reading, minds spoke to him across the ages with immediate urgency. He sought communion with them through his drawings.

Having finished a series, he would throw them the next day into one of the many old trunks in the attic, sometimes tied in bundles with a piece of fishing line, sometimes loose. He never went back to them.

He was at this time also doing a great deal of rather flat, stylized, primitive painting, using color that was very bright, very strong. He was experimenting too with the aura of light and color that he could see around a figure or an object; he circled his flowers, for instance, with the colors of the spectrum, surrounding them with rainbows. The effect was in harmony with the brilliant sun and pulsing waves of heat of the Mississippi coast.

He drew and painted in an effort to get everything down before it vanished. He often took his sketchbook and ranged about the countryside, frequently disappearing for a day, a night, or more. From one of his trips he returned in rags, blackened with smoke, his arms blistered.

"My God!" I said. "Where have you been?"

"Fighting a woods fire. Don't look so distressed. I'm fine."

It took me three hours to clean him up and doctor his burns. Aside from the healing of his body, it was time well spent. As I cut away the rags and removed the smoke, he talked as he luxuriated in the tub of tepid soda water.

"It was so beautiful," he said. "You can't imagine. Oh, it's spring and it's so absolutely tender. The sky was so soft a blue, the little clouds like Christina Rossetti's sheep, all the

new green and the flowers so delicate, the bird songs so loving. That's what made the fire so ghastly."

"Where were you?" I asked. I wondered how far he had come with the iron-hard soles of his feet covered with open burns to which the rubber of his tennis shoe was stuck. He had not flinched as I worked away.

After he left Oldfields, he said, he went northwest over the cutover land. "It was barely dawn, with stars still out. I could see the lights of Bob Havens's house. I knew Mrs. Havens was up getting breakfast for the sheep workers and I veered that way, knowing that she'd give me breakfast. Then the sheep started bleating like watchdogs when they saw me, and Mr. Havens came out on the back porch and asked me in. 'Thought you might be that ornery boy s'posed to help with the shearing,' he said."

Bob said he asked them to let him help, and they did. One of the boys showed him how to corner a sheep and catch it by the front legs, flipping it over and grabbing the hind legs to hold it on its back.

"My first try worked perfectly, and I thought it was going to be easy. There were three of us to catch, but we were hard-pressed to keep up with the shearer. After we finished I got my clipboard from the porch and followed the sheep across the meadow. They were drifting across the pale grass in exactly the way the clouds were drifting across the pale sky. I would sit on top of a little round hillock and take turns drawing and watching them. All the time, I was drifting closer and closer to the highway."

Bob said when he got up and started home he saw smoke rising over near the highway. "I ran like the devil till I reached the edge of the burn. I broke off a young pine sapling and began beating the flames. That one became a useless stub in my hands, so I tore off another. Each time I did this I begged the little tree to forgive me. I don't know how long I worked. The fire swept across miles of cutover land. I have the terrible feeling that my friend Mr. Havens set it. He wants

fresh grass for the sheep after the winter's dry brownness. He has no feeling for the death of the hundreds of small pines that struggled into existence to reforest that scarred land."

After the fire was out, Bob said, it was sundown and he crossed the highway and went to bed in a culvert that was dry and protected. He slept well and walked fast to reach the bayou at sunup. The water was cold as ice, but he swam across and back.

"I did a sun dance before I put my clothes back on. Then I found one of those little hidden dells and lay on my back in the sun and warmed up. There were lots of birds all around in the grass and in the little trees. When I saw a prothonotary warbler sitting on a low branch, I was overcome by love for him and I said to myself, 'If he loves me, he will come down to me.' It was as if all my chance of happiness depended on it. But he did not come to me and I realized that he did not know I was there. I sat there and my love to him poured out more and more, and, lo, he flew down to a stump, and then to my knee. I knew beyond a shadow of doubt that the important thing is the love that goes out from oneself."

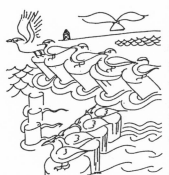

While we were at Oldfields I was continually getting the impression that Bob was a new creature coming from some far, strange place where he had been dipped in a river or had suffered a sea change. He seemed so new to all the things of living.

One night, in the fashion of all who assume responsibilities, I waked in the wee hours to see lights still on although we were under a wartime blackout. I sallied forth to beard the lion in his den—Bob in the dining room, where he spent

many hours reading and drawing. I knew that there would be an edge of anger in my voice before I opened my mouth. He opened his first.

"I was just wanting you," he said. "How wonderful that you should appear. Come, we have a trip to make before the morning. Who knows to what far places?"

He grabbed me by the arm and hurtled me through the front door onto the gallery. The moon shone in under the eaves; low in the west it was becoming morning.

"Bob, Bob," I was imploring. "Let me go. You know I can't leave the children."

"The farness we reach will be in our hearts and minds," he said. "You can hear the children from the pier, but you and I can rush among the stars."

The old gate was left open behind us. We sank to the rough planks of the pier.

After a while we were lying side by side just beyond the covering branches of the small oak. The whole sky was spread above us, infinity beyond the paling stars.

"I love you," he whispered. "I had forgotten how to say it. I suppose you've noticed. I've forgotten so much. I'm starting to learn all over again and I'm just not sure some of it is worth learning again. Far places are connected with truths, and I have been very far, farther than the farthest star.

"There was pain in the rushing flights," he continued. "Can you imagine flight beyond the farthest star? The bursting lungs? The shivered eardrums? The eyes blown from their sockets? Those doctors gave me something. . ."

I could see that he was looking down at me with a questioning look. Did it hold something of suspicion, something of anger? The doctors at Phipps had told me not to tell him that I had signed the paper for his treatment with the drug Metrasol; I had never told him. It was a silent betrayal that I could not reconcile. I was about to blurt it out.

"I'm glad I did it," he went on. "It made me get well. It was so terrible and so thrilling. There was the terrible pull

not to come back from those beautiful distances." He sat up for a moment and pulled me up, too. "Look at the end of the pier. I have found that it is as far away as the stars when you must listen for the baby's cry. Time and distance are relative."

He kissed me very gently. It was like a pardon.

"I'm glad I did it," he repeated. "It made me decide to get well."

Chapter Eleven

Shortly before the war started I contracted to have electricity brought to Oldfields. The REA lines were snaking over the rural portions of east Jackson County. Since every shack, every fishing camp, every little farm would soon have electricity, the iceman's truck had ceased to run. We had been driving to the ice house in Pascagoula to keep our old icebox full. Now gasoline and even kerosene were to be rationed, and electricity seemed the only answer.

While we were still struggling with the problem of ice, Billy, still a baby, became very ill on a day when I had gone to New Orleans with my sister. The children had been left with Susie, a loving and familiar presence who had been with the family for years, so I had anticipated no problems. Bob was there, as was my father, though I considered that both of them were more or less detached from any household activity. I got the story of what happened from Bob.

When Susie went to wake Billy from his morning nap, she found him writhing with a stomach ache, suffering from nausea and diarrhea. When she picked him up, he screamed

as if in pain and refused his bottle. His grandfather became agitated and tried to hold him. Then Bob descended from his attic workshop. "What's going on?" He took Billy and laid him over his shoulder.

For a while the baby became quiet, then his agony began once more. "This child needs a doctor," Bob cried, and he was off to the car and away before anyone could stop him. He grabbed a bath towel as he carried Billy out of the house and laid him on it on the front seat. Driving with one hand, he managed to keep him on the seat the fifteen miles to Ocean Springs, where he counted on finding help. But the doctor's office was closed. The baby no longer had the strength to cry.

Driving over the bridge to Biloxi, he hurried to the hospital, where the nurses sent him to the emergency room, calling for any doctor in the building. There were two of them; they both came immediately and began to work over the child. One gave him a shot; a nurse sponged the little body with cool water.

On relating the incident, Bob murmured, "How I hated those feeling, poking hands, the needle to draw a sample of his blood. I wanted to grab Billy and run."

When one of the doctors came back with the report from the lab, he asked, "Where is the baby's mother?"

"Away," Bob answered.

"Then you'll have to make the decision, Mr. Anderson. The white cell count is very high and, together with other symptoms, points to acute appendicitis. I would advise immediate surgery."

Bob picked up the baby and started out of the room.

The doctor stepped in front of him. "I think this is more serious than you realize," he said. "This is probably his only chance."

"Oh, no," said Bob. "I've got to think about this."

"There may not be time," said the other doctor.

Bob rushed to the car and started back toward Old-

fields. The way home led, after a while, across the old wooden bridge over Davis Bayou. It was a favorite place of his, one of his "nullahs," a spot where he received refreshment and renewal and where now, with his little son, he stopped. The baby did not seem to be conscious, but he detected the beat of his heart in the vein at his temple. Suddenly he knew what to do.

"You'll be fine now, Billy." He carried the baby down the muddy slope beside the marsh. Around the curve of the marsh he stopped. Gently, he lowered Billy into the water. He sat cross-legged in the shallow pool; the baby rested on his knees, swaying slightly in the current from the rising tide. The sun shone upon them; the breeze fanned them.

"I did not pray," he said. "It was deeper than that. I think that Billy and I became one with the time and the place and with whatever beneficent genie presides over nullahs. Presently he opened those huge green eyes of his and smiled at me."

From then on, all was well. Bob kept Billy in that nullah most of the afternoon, until the sun began to set, a chill came into the air, and Billy began to fret with hunger. Then they went home to Oldfields. Bob gave his son a bath and dressed him in a little nightgown of Mary's.

"Get your brother a bottle," he said to the watching three-year-old. She ran and asked Susie for the bottle, and Bob held Billy in his arms and fed him. When the bottle was all gone, Billy was asleep and Bob put him in his crib. To my knowledge, that is the only time he ever fed a baby.

When I returned that night, the household was too exultant over the happy outcome to talk much about the frantic worry. Not Bob. He appeared to be completely exhausted, drained. After the children were in bed and I lay, weary, upon my own bed, he came and lay quietly beside me. "I want to tell you about today," he said. "I think I did the right thing." He stopped. Then, "Let's go look at him."

Billy lay sprawled out in his usual fashion, all the covers

kicked aside, his head pressed against the side of the crib. Bob leaned over and kissed him. He even stopped by Mary's bed and put his lips against her curls. We went back to my bed, and he told me the story of the day.

The next morning there was a note on the dining room table: "Gone to Chandeleur Island." He had taken his boat and departed.

 Horn Island was always the favorite destination for his offshore trips, but with the onset of the war he shifted his preference to Chandeleur. The choice was made for him by a series of tragic-comic circumstances that he recounted after a trip he made in the latter years of the war.

Considering the length of time he had struggled to bring himself and his borrowed skiff from the island, I was not alarmed that he slept for twenty-four hours. When at last he stirred, he was in a wonderful state of relaxation. The tales of adventure came rattling off his tongue. The children were open-mouthed and incredulous. Even Daddy perked up and showed some interest.

"I was not really thinking about what I was doing," Bob said. "I realized that the tide was running out pretty strongly and that the wind was against me as I came off the west end of Horn Island. I was used to that passage, but suddenly I sat straight up in the boat. I was almost sure that I had seen a big police dog on the beach of Horn Island. Now, how on earth had that poor creature reached the island? What must I do to rescue him? Just then the current caught me; the wind shifted in a puff, a hard one. The boat went over before I had time to think.

"There was a terrible undertow," he said. "I had to let

the boat and all the things go to get to the beach. But the dog would not let me land! With his fangs showing, he dared me to come near. It had been a fight to get away from the current and my breath was coming in gasps. I was swallowing water. In fact, I gave myself up for lost, for I quite distinctly heard the sound of a train coming. Since that was an utter impossibility, I knew that I was already unconscious. Then through the wind and spray I saw the train, far down the beach at the other end of the woods. I saw two soldiers with guns at the ready, advancing down the beach as if they were in pursuit of a dreadful enemy. I glanced over my shoulder. Nothing but the cruel sea. I realized, with a shock, I was the enemy!"

"Halt! Don't make a move. What's your business on this island?"

He told them his boat had turned over in the cross-tide. "I'm drowning."

Obligingly, a wave filled his mouth and nose with stinging salt water and he did a bit of strangling. One of the men was talking out of the corner of his mouth into what Bob learned later was a walkie-talkie.

"Come with us."

Actually, Bob said, they had to help him out of the water. " I was ashamed of my weakness. With one of them hanging on to each arm, we straggled down the beach to the train. It was a locomotive with a car running on a narrow-gauge track laid across the sand on heavy pine crossties. I began to shiver violently when they loaded me into the car and set off east through the island undergrowth, which had been pushed back to allow a right-of-way. I cannot possibly express the fear that came over me."

They came to some sort of military installation and he was taken before the commanding officer. Everybody was saluting, he said, so he saluted too.

"Identification?" the officer barked. "Coast Guard card required of anyone using the territorial waters of the United States. Where is your card?" he asked.

Bob told him it was with all his equipment and his boat, washing around out there at the end of the island. "If I could get a little help, I think I could get most of it back."

"What is your name?"

"Bob Anderson."

"Where do you live?"

"Ocean Springs."

"Where were you going?"

"North Key, Chandeleur."

"Why?"

"To observe and paint the nesting pelicans."

The man spoke to a young officer sitting beside him, and the officer got up and went out.

"What is your profession?"

"I'm trying to be an artist."

The questions went on and on. By then Bob was beginning to be able to see how funny this whole thing was. He looked at the officer and said, "Why did *you* come here?"

"Good Lord, man! Surely you don't think I wanted to?"

"I sort of exploded," Bob said. "I told him, 'You have ruined the most beautiful place in the world. I can never forgive you.' He drew himself up. 'We are doing research essential to the war effort.' He put out his outrageous claim as if he meant it, but I knew that I was saved. He had spotted me for a 'crazy.' He invited me to have a chair. I sat in stubborn silence contemplating my navel."

Finally the two soldiers returned. They were wet and they carried Bob's garbage can. There had been some seepage.

"I blessed you," he said to me, "when my I.D. card turned up in the bottom of the can where you had put it. They extended no further hospitality after that. I was put in my retrieved boat and shoved off. I tried to shake it out of my mind and had a perfect sail out to Chandeleur, despite the less then ideal beginning of my trip."

Because of all the delay, he reached North Key in the wee hours and was so weary that he tied the anchor to the rope and threw it over but neglected to tie the rope to the boat. Luckily, he had brought his gear ashore, because the next time he woke up the boat was gone.

"Daddy, you were marooned!" said Mary.

"Yes, and it was lovely. It made everything just that much better, being on my own as much as, or perhaps more than, any other creature there. I think I became rather a human pelican. I was sure I could understand their language. I had never known they had one, thinking of them as silent creatures in contrast to the noisy gulls and the songbirds."

He said he became so immersed in the converse of the parent pelicans with their young that he made an attempt at writing down the sounds and their meanings as they became apparent to him.

"Daddy," asked Mary, "what did you eat while you were marooned? Did you catch fish?" At that time Bob did not eat anything whose life might have to be taken to satisfy his hunger.

"Well, no," he said, "I didn't have anything to fish with, but I did sometimes eat fish if it washed up on the beach or was dropped by a mother pelican trying to get away from a greedy frigate bird. That is, I ate it if I could get to it first. But I had brought my garbage can to shore when I landed, and all my rice and beans were in it. When the boat drifted away, I lost my gunnysack with the canned goods. I ate some roots of bullrushes and shoots of marsh grass and even some tubers from bamboo vine, greenbrier."

Bob said there were salt grass dewberries, too. "I didn't suffer. On the contrary, when I saw the first fishing boat I became horribly depressed. The poor men were upset when they found me. They were sure I was a survivor from a U-boat sinking. They wanted to take me in, but I refused. I sent word for someone to bring me a boat. How I hated to leave. Every-

thing on Chandeleur had been so defined, so limited—but not at all the limitation of a prison or a hospital, which seal in and shut out. On Chandeleur, there was the feeling of being released into a new dimension, that dimension occupied by the free-fliers, the free-swimmers."

Some time later I heard Mary saying to a visitor, "I don't know." Her answer was in response to a query put to her by a clergyman to whom she had been describing, in great detail, the beauty and excitement of Chandeleur Island.

"Mary, have you been there?" he had asked.

No wonder she didn't know. Her father's tales and his paintings were as vivid as a presence on the beach.

 Late one summer evening I awoke after I had gone to bed. Outside, the insects were like a full orchestra. How many separate and distinct voices was I hearing? I began to enumerate softly to myself: crickets, katydids, grasshoppers, locusts, click-bugs like castanets. Suddenly the insects made me think of a duty to perform. I was on my feet beside the bed, feeling for my mother's old straw slippers with the cross-straps. I crept to the front screen door, hoping it would not creak. The spring gave a tiny "ping" as I closed it. I listened, but there was no sound from the sleeping little ones.

Then I saw the light spilling from the dining room window. Would he never learn that there was a blackout? Tipping along the length of the front gallery, I shivered briefly with the beauty of the starlit night and the lovely bulk of the beautiful old house.

Bob was sitting at the dining room table, as I had known

he would be. I had also known that there would be coffee, for I had begun to smell it halfway down the gallery. A book was lying open before him. Around him was a sea of drawings, but that was no pen in his hands. It was a spoon. A drop of café au lait hung from the tip. What must have been one of the world's largest oaktree cockroaches was standing on its back legs on the table, its front ones grasping the sides of the spoon as it drank from the pendant drop. The hand that held the spoon was as steady and as gentle as a mother's teaching her infant to eat.

I burst in upon the idyllic scene.

"You promised me you wouldn't do that any more!" I wailed. "You promised. I'm going to kill him. I AM."

Bob knew that he was safe. He knew that it was impossible for me to swat a roach. I was engaged in my own private war against them, but it was not a war of mayhem but of slow poison. I contended that they were dirty and spoiled many of our meager wartime supplies.

He rose now, putting the spoon down very slowly so that his friend would not be disturbed. He took me gently into his arms. "They do no harm," he said. "They have lived upon the earth's surface far longer than we have and are due a little respect. Besides, this one is my friend, and particularly intelligent."

I snatched off Mama's slipper and came heavily down upon the roach.

"You shouldn't have done that," he said very evenly, forcing me backwards toward the door. The whole front of my body was pressed against his. In a minute he had picked me up and was carrying me down the gallery, across the lawn, down the pier. Was he going to drown me? He was completely overpowering. I saved my breath for the struggle that I imagined was imminent. He reached the platform at the end of the pier and laid me down with utmost gentleness.

"Good God!" he said. "Don't look at me like that. What

are you afraid of? The roach doesn't really matter. He was very old; he didn't have far to go. Feel the north wind; winter is coming."

Yet in the back of his eyes I saw that he had shared my fear. Now the danger was past and he was kneeling beside me.

"I love you," he whispered, quite overcome by his desire. "I love you so."

Chapter Twelve

It was Christmas 1942. All over the country people were trying to put the emphasis on the "Merry," with hearts like lead from fear, worry, pain, and loss. At Oldfields, there was still the remoteness experienced by those who live in a world of their own, whose hearts are operating on another rhythm.

The wish book, Sears Roebuck's catalog, came. So many wonderful things, some costing small fortunes! Finally, I had chosen: Indian suits for Mary and Billy, with real feather headdresses; for Grandpa a warm gray sweater; and for Bob and me sweat shirts, his green, mine red. Reuter's, the New Orleans seed catalog, was out early; everyone was ordering packets of seeds. I ordered something new for Bob called "tithonia," the gold flower of the Incas.

Christmas Eve day Bob transformed the hall at Oldfields. The hall was a shut-away place in winter, cold as a stone, no heat in it. It ran right through the middle of the house. On each end, double doors opened onto the front and back galleries. Bob cut a small pine and put it up for a Christmas tree.

I exclaimed with delight when I saw the bamboo stars he had made to adorn it, and protested when I saw the holders and the candles.

"Don't worry," he insisted, "they will only be lit when you and I are here."

Dozens of branches of pine, holly, yaupon, and mistletoe were everywhere, but not just as Christmas decorations: they formed what would be a forest for a pair of very small Indians and their friends. After the children were in bed that night he brought out the secret he had been working on: a tepee. It was made of brown burlap feed sacks, painted superbly with all the symbols of an authentic tribe. He placed it in the miniature forest, which needed only a couple of Indians to be real. In the morning it would have them.

"Darling, darling . . . I love you . . ."

I finished draping the popcorn string on the tree and we slipped out the front door onto the gallery. It was near midnight. The sky was very bright and the weather had changed. The wind was blowing in from the water; it felt almost warm.

"Let's go to the barn!" he cried. "I've always wanted to watch the cows at midnight on Christmas Eve. They are supposed to kneel and pray, you know."

He caught my hand and we leaped down the steps and ran across the yard, down the pasture. We crept, hand in hand, the few last yards and stood in the opening. There were two cows lying down inside. As our eyes became accustomed to the darkness, we could see the rhythmic motion of their jaws.

"Just a little too early," Bob said. "Come with me."

We eased along to the loft ladder and climbed up. We sat on the edge of the loft, watching like two children. How still it was! Not even the squeak of a mouse. Suddenly both cows began to move, unfolding and kneeling up on their front legs. I remember thinking: But cows alway get up like that. At that moment Bob bowled me over in the hay and

said, "It's true. Oh, it's true!" and we were making love with the hay tickling and with such an ecstasy upon us both.

"It's Christmas," he said. "Merry, merry . . ."

And when he said it, I cried out. "Yes, and I'll bet Mary's awake!"

We dashed back through the quiet night, surprised to find that it was almost dawn. A little drizzle of rain was obscuring the brightness, and clouds were coming up fast.

The house was quiet and we slipped into our separate rooms. He stuck his head in while I was taking my bath. "I'm going out for some coffee. Want some?"

"My goodness, no. All I want is sleep."

He grinned and was gone.

The mood lasted all through that marvelous Christmas. I don't think I have ever seen children so completely fulfilled on Christmas. The cousins came from Ocean Springs in the afternoon, Michael and Patsy and Moo. How wonderful that it should have been warm; how wonderful that the rain fell outside and that the inside forest held so much of joy.

My sister Pat and I gave them an early supper: soup and toasted sandwiches, cookies made in the shapes of Christmas trees.

Pat's family drove off in the truck before dark. The children were asleep as soon as the light had left the sky, Billy in the tepee with his brave's feathers jammed over one eye.

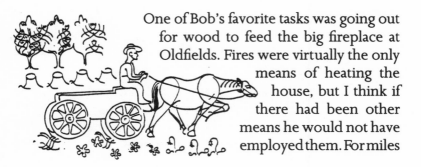

One of Bob's favorite tasks was going out for wood to feed the big fireplace at Oldfields. Fires were virtually the only means of heating the house, but I think if there had been other means he would not have employed them. For miles

around Oldfields, on the cutover land where stumps of the great pines had been left, was a rich store of fat pine.

We usually went wooding in the evening, in the pause between the end of work and suppertime. Bob would come down from his attic studio, fill his pockets with nuts and prunes, gather up the children and me, and off we would traipse to the barn. Old Jim, the horse, was very fond of him. The red and green farm wagon had "Florence" written on its side in flowery letters; it had been manufactured in Florence, Alabama.

The children spoke of Florence and Jim as of a wife and husband, friends with whom a pleasant afternoon could be passed. I remember telling an acquaintance that sometimes friends seemed very far away at Oldfields, and she replied, "Well, what about Florence and Jim? They must be pretty close. You see them all the time."

Yes, we did.

We all climbed up onto the high front seat and were off to our destination. Once Bob stopped by a black thorn bush, not yet in flower, where a shrike or butcher bird, as we called him, was impaling a lizard, still quivering, on a thorn. Mary and Billy cried, and Bob said roughly, "The world is not a pleasant place, but so beautiful, so wonderful . . ."

At the top of Molly's causeway we all got out to marvel at the mourning cloak butterfly fanning the dust of the road with its new wings. When we got to the cutover land, Jim was given his head to crop the grass while Bob began chopping wood and loading the wagon.

The children and I gathered pine knots. They were so beautiful that later we hated to burn them—worn bits of wood, gray and sculptured by wind and water, often to shapes of birds or heads. We gathered them for their brief flare of warmth on a fire. Perhaps, as spring advanced, we would come back with a plume of swamp maple, shaking out the brilliant red wings of its seed pods, or a knot of white violets, or penguiculas, or a sheaf of pitcher plants. We all walked home. Old Jim had enough of a burden with the wood. We

had to trot and run to keep up, for Jim was on his way home to supper.

When I gather pine knots now, I cannot bear to put them on the fire. I put them in a paper bag and shake them on the flames without feeling or looking. Oldfields has been sold. Bob is gone. The children have children of their own, and gas heat in their snug little houses. But the wonder has not gone from their eyes. Their children have eyes of wonder, too. The mourning cloak still fans its wings at the top of Molly's causeway hill. I have not seen it, but I know that it is there.

Everything was in short supply during the war years. Living in isolation, we did without a lot of things. The cumulative strain of making-do finally wore me down. Over and over again, toward the end of the war, Bob said, "Why are you so cross? What have I done?" I said I was not cross with him or the children, but with myself. This, to be honest, was about the closest I came to the truth at that time. I felt I was bearing horrible burdens.

One was the care and control of a man with a history of mental illness, still a person apart. Why did it take me so long to learn that his apartness came from his genius and a truth in his life I could not see? My other charge was my father, who was senile. Bob could never accept the way Daddy sat, day by day, in the isolating depths of his misery. Bob had to poke and pry; Daddy's reaction was often violent.

At least, I thought, the children are happy. Mary was happy until she went to school for the first time. The world of her freedom and imagination crashed about her. To say

that she was unhappy is the worst kind of understatement. In order to spare the other children, the teacher was forced to let Mary spend her time under a pine tree in the school yard. One tree! She was used to hundreds. She had been reading for years, amusing herself with drawings, and writing. Nothing seemed beyond her ability except sitting for hours and doing silly things that someone else required of her. She howled at school and came home a limp rag, only to regenerate immediately into my fairy child.

My heart was wrung for Billy, too. He was growing like a weed. At four he was able to do anything, and as the year progressed I depended on him for many duties. He loved getting wood. He enjoyed scrambling eggs. He swept with abandon. He fished and crabbed, dug potatoes, picked berries, contributed amazingly to the larder. He was my rock. But our roles seemed reversed, and this made him rather serious and big-eyed.

In the midst of these frustrations I realized that I was pregnant. Bob remained violently opposed to bringing any new life into the world. I was afraid to tell him I was expecting another child, and kept hoping the symptoms would go away.

I argued violently with my God about this new little being. Three months went by. Money was so scarce we were all feeling a dreadful pinch, and I asked my father if I might sell some trees.

"Do what you want," he said, "just don't bother me."

I arranged for the sale of the trees to Mr. Cumbest, who ran a sawmill in Moss Point. One morning in May I woke to the sound of the sawyers and realized I had forgotten to tell Mr. Cumbest that the line trees, two huge old pines, were not included in the sale. I leaped out of bed. No one was about. Besides, I could not entrust this errand to Bob, who was bitterly opposed to any tree-cutting at all. In any event, when I glanced out the front window I saw the sail of his boat far

off to the southeast. He was headed for the Chandeleur Islands, to the pelican nesting ground.

I pulled on my clothes and dashed out the back door and down the road. How short of breath I had become; I hardly had the strength to lift my feet. I found Mr. Cumbest unloading his men and equipment from a big old truck. Five or six beautiful oxen had arrived from Vancleave and I thought how sorry Bob was going to be not to have been here to draw them.

I walked out to the road with Mr. Cumbest and pointed out the two line trees. Then I hurried back up the road. Mary had to go to school, there was lunch to make, her breakfast to fix. Oh, God, there was such a pain in my side, my stomach!

By the time I reached the bathroom there was an explosion from my tortured insides, and suddenly there was blood everywhere. Of course I realized what was happening. No hymn of praise and thanksgiving to a good God who, apparently, was answering my prayers rose in my heart. Instead, I was overcome by a crushing feeling of guilt. At the next wave of contraction, I caught the tiny fetus in my hand. I remember thinking, numbly, that it looked like a little seahorse. I was beginning to feel faint, and somehow at last I lay down on the bed, pulling the sheet up to my neck. I was so cold; then I sank into semiconsciousness.

There was a hand on my shoulder. "Mama!" It was Billy. He had syrup on his mouth. I drifted away from him.

My next visitor was Verna, our neighbor. Billy had run to get her. "My God, Miss Sissy, you sure are losing a lot of blood. Was you pregnant?"

I nodded a feeble head. "Verna, could you get someone to call my sister in Ocean Springs?" She was gone.

In a little while she came back and arranged the bed again. Then she was holding up my head and feeding me hot tea full of sugar, somebody's rationed sugar.

Robert, who took care of my father, came next. "Miss Verna done called Miss Pat," he told me. "She's coming. The doctor's coming soon. We be having you fixed up. Jes' you lie still, I take care of everything."

Bless him. How often Robert still took care of everything. How wonderful to have such a friend from childhood.

I recovered, but it was through no effort or desire of my own that I came back. With my whole being I longed to escape, but I knew that quitting was a sin and that I had sinned enough for now.

I think it was early November when I was shaken with the hidden knowledge of another pregnancy. The sun in its yearly march dipped down in late afternoon, bathed the wide front gallery with cool light, and sent its fingers probing into the front bedrooms. Bob came to me as I entered the pantry. I suffered from "morning sickness" in the late afternoon. I was getting ready for supper early.

"Put that back in the refrigerator," he said. "I need you." He saw my reluctance. "Quick," he said, "it won't take long." Already he was pulling me through the hall to his room. "It's the light," he said. "It's absolutely perfect." He was pulling off my clothes, pushing me up against the wall where the sunlight slid too swiftly.

"Oh, Bob, I just can't pose now."

It was almost a sob, born of relief that it wasn't sex he wanted and fear of the already visible bulge.

"Yes, you can."

He had pulled me into a pose. As he worked the light faded quickly. Soon he was drawing in deep dusk and I was fighting to control my nausea. Finally, he said, "That's all. I can't see."

I picked up my clothes and ran across the hall to the

bathroom. When I came back, I was dressed. He sat with his head in his hands.

"Bob, what is it?" I asked.

"I don't think you can understand," he told me. Now he smiled. "I'm an artist," he declared wearily. "It comes over me like a physical craving, like hunger or sex, a necessity, a burning, a pulling of the thread tighter and tighter. Anything can trigger it. With me, it's nearly always the light. What it can do to flesh tones, how it can change the beauty of a curve. I feel as if I might die, disintegrate, if I can't record the image." He took me in his arms so gently. "Thank you," he said, "I'm a selfish brute. I didn't know you were sick."

"I'm not sick."

"I heard you in the bathroom."

"I think we're going to have a baby."

He was kissing my hair, my cheeks, my neck. "He will be little Leif!" he murmured. "Oh, I'm glad. How long do we have to wait?"

I was weak with relief. I had been terrified to tell him; now it was all right. I thought I would melt with happiness and thankfulness. When I got back to the pantry, I heard him singing. It was not the usual *Seventh Symphony*—what was it? Ah, "The Ride of the Valkyries," loud and rushing with the rising winter wind. "My little Leif" . . . Erickson, of course.

I was happy. Nothing could spoil it.

Chapter Thirteen

In April, on our wedding anniversary, we took the children on a noon picnic to Graveline to celebrate.

"You haven't told me when my baby is due," Bob said.

"It will be after the fifteenth of May," I told him. "There is no way to predict an exact date, you know."

"This is a boy," he declared, for the hundredth time. "An adventurer, a traveler upon the face of the earth, a discoverer. That is why his name is Leif."

I didn't argue.

"Do you think I have time for a quick trip? I promise to be back in a week," he pleaded.

I knew that the nesting pelicans on the Chandeleur Islands were drawing him like a magnet. He had never been present for the birth of a child. Why should things change?

"I'll wait for you," I said. "Go watch your little pelicans crack their eggs."

He was all joy in an instant. "I love you!" he said, and

was off within the hour. So it was that a few weeks later my family moved me to Ocean Springs.

"You can't stay at Oldfields without Bob to help you," my sister insisted. "That baby will be here any day now."

It was true. But I wanted to be there when Bob came back. I wanted to see him sail in at sunset, dragging his oar and pushing over the sandbars. What I said was "Who will take care of Daddy?"

"Don't be an idiot," said Pat. "I will, with Robert and Susie. They can stay with him at night for a couple of weeks. Everything will be fine."

So I was gone when he came back from the island on May 22. Bob walked and ran all the way from Oldfields to Ocean Springs, fifteen miles. It was early morning when he reached his mother's place.

Mère called the hospital and got Pat. "Tell Sissy that Bob is here. He must have come in yesterday in all that storm and walked over here from Oldfields. He's very much excited, but utterly exhausted. He has passed out in the chair."

"Is he coming?" my sister asked.

"Yes. I had to stop him from leaving at once. We'll be there as soon as I get dressed."

When Pat brought me the news, my heart gave one great leap of joy, then settled down to its usual questioning. What would this do to him? Could he take the stress? What if this baby turned out to be a girl? What would he do? Oh, God, what did it matter?

Like each of my other labors, this one seemed to be stretching out to eternity. The pains were so fierce and frequent that I was trying to persuade the nurse it was time to go to the delivery room when Mère and Bob burst into the room.

"What is it?" Bob whispered. "What's the matter? Aren't you glad I came?"

I tried to smile. "So glad," I murmured. I reached out my hand to him. He laid his cheek against mine.

"Please, I don't want you to hurt!"

I knew nothing of the joys of natural childbirth. Labor pains to me were pain, pure and simple. Now they combined with exhaustion and I was losing most of my control.

Bob appealed to his mother. "Can't something be done?"

"Babies," said Mère, "must be allowed their time."

He ran out of the room. In a few minutes he came back with the nurse.

"She's fine," assured the nurse. "Just wait in the lobby or go get a cup of coffee. It will be about an hour."

He groaned and both of them, with obvious relief, left.

"This baby," I told the nurse, "is coming now."

She brought a stretcher and got me on it, wheeling off down the hall, calling a nurse to come with her. We were in the elevator when I felt the baby's head between my legs.

Much later, I found that it was a girl, almost eight pounds, with broad shoulders. I was back in the room and asked where Bob was.

"He's hanging down there at the nursery window, gazing at her in an absolute ecstasy," said my sister.

"He's not angry because it's a girl?"

"He certainly doesn't seem to be."

Leif was Bob's from the beginning. She spent a great part of her first year with him. Lifted out of her crib at random times, she was deposited on his floor. She learned to listen to the music of his record player and to sleep to the vibrations of his dancing. As soon as she could sit, he had her dancing from the waist up.

Leif became a dancer, perhaps closer to her father than any of the other children.

One Sunday in late spring I decided we should go to church. I got myself and the children ready, found Daddy amenable, and tackled Bob. He was feeling kindly toward his wife. After

all, for the first time in his life he was joyous about the birth of his child. He dressed himself and we all departed in the old Ford for the chapel, two miles away at Gautier. Mary was carrying flowers for the altar. She had just enough time to place them in the vases before the service. Surrounded by my family, I went into a sort of religious ecstasy. The children had a hard time prodding me loose afterwards, and I was truly surprised to find that Bob had disappeared.

Daddy leaned over. "He's outside," he announced.

Sure enough, he was. The day was not the kind for crossness, but I was a little annoyed.

He came to me in the afternoon. "Could you and I take a little walk together? Arrowheading, if you're not too tired."

We went. I was tired. I was always tired. When we reached the pine bluff at the Chestant Place, we sat down to rest. The wind was singing in the tops of the pines. A migration of small birds was chirping in the bushes. Out over the water, terns were wheeling and diving.

Bob put my head on his lap. His voice was low and vibrant with the caressing quality it assumed when he was moved. "I love you," he said, "probably more than ever. Please don't be hurt by what I have to tell you."

He was feeling the curve of my ear, my cheek, touching my hair.

"I'm glad you made me go to church," he said. "I got some things straightened out. I know how you feel because you and I are really one in a very special way. We can't escape this. We always will be. Still, I have to say this."

He picked a long grass and ate the sweet spring stem that had sprung from the root. "I know what you want for me." He sighed and stopped. "What do I want for you, my darling?" I asked.

"Normalcy. All that you give yourself for is to see that I remain normal, to see that I live in the world and not in a hospital." He paused.

It was true. I was aware of the role I had assumed, to screen my two "crazy" men from contact with a society that might condemn them.

"I am grateful for these beautiful years," he continued, "but you have to understand something, too. I *am* normal. Mine is not the normalcy of church this morning. It is not the normalcy of schoolteachers and guild members, of bankers and storekeepers, of people who work at Ingalls Shipyards or go to war. Even though I don't condemn it, I don't think I want to be that kind of normal. I only feel great grief that there should be no alternative; I intend to make my own. Oh, darling, don't be surprised at what the years may bring. Know that I live under a different compulsion. I must be in harmony with this . . ." He waved his arm, encompassing the earth. "Not only must I be in harmony, I must make it manifest."

I understood to a certain extent, but I was frightened. "What do you mean, don't be surprised?" I asked. "What are you planning to do?"

"I must paint," he said. "I am going to try to order my life so that this becomes possible." Suddenly he was pulling me into his arms, holding me tight against him, crying, "Give me your blessing! Oh, give me your blessing. I am like Jacob, and you are the angel."

I gave him my blessing.

Suddenly the war was over. With rationing gone, consumer goods were back in the world. Bob came home from a trip to town one evening looking disturbed. "Good Lord," he said, "you ought to see the things that people are buying in the name of *art*. The hideous prints, the ornaments. Things for children's rooms that ought to make a child sick."

The large block prints were born.

"There should be simple, good decorations, to be sold at prices to rival the five-and-ten. What about a well-designed fairy tale for a child's room?"

Surplus stores were full of rolls of heavy battleship linoleum. Bob bought all that he could and cut it into large pieces which he carved with intricate designs. A friend had sent him many rolls of faded wallpaper from surplus stock put away during the war, and he used the back for printing the blocks.

Up in the attic he worked day and night at his carving. At the foot of the attic stairs each day a mountain of linoleum chips awaited the broom. One morning it was so high that I went to the barn to get the broad shovel we used for cleaning there. I hosed it off, but it had nestled in manure for generations and bore the odor. Bob came down the stairs looking furious and said, "Get that thing out of here. It smells to high heaven."

"Yes, God," I replied rather sharply. He wheeled, retraced his steps, banged the door at the top of the stairs, and disappeared.

I mounted the stairs at lunch time to find that he was not in the attic. No one had seen him all morning.

Oh, well, I thought, he'll be back. Then I froze. I remembered that his eyes had been upon my stomach when he came down those stairs. I was pregnant again, and had not dared to tell him. Anyone else would have noticed it long before.

That night he was in his accustomed place at the dining room table. I brought in the salad bowl and said pleasantly, "Just about the last of the lettuce. I had to augment it with eggs and a bit of baby spinach."

Suddenly Bob pushed back his chair and rushed from the room. The rest of us finished our meal quietly. Mary had brought a nagging cough home from school. It was mid-December, and the first really cold weather had set in.

After her bath I rubbed her chest with Vicks VapoRub. She had dutifully gargled with antiseptic before she went off to bed.

I was sitting in front of the fire, dozing, when Bob came in. His face had the hard look it acquired when he was particularly tense and irritable. "Make that child stop coughing!" he barked. "I want to sleep."

I went to Mary, gave her a bit of Vicks, and sat in the cold room, crooning and hoping to be effective. She continued to cough. Back he came, grabbed the child by one arm, and marched her into the bathroom. "Now, drink this!" he shouted. "Drink until you can't cough any more!"

The water spilled down her little flannel nightgown. She stood shivering and looking at him, frightened and uncomprehending. Again and again he made her drink.

I could stand it no longer. "Bob, stop it! She'll be up all night. That won't help her cough at all!"

He threw the glass at me and again was gone. The other children had waked and were crying. I built up the fire in my room and took Mary into my lap to change her clothes. Leif crawled up beside her. Billy brought a quilt and snuggled at my feet. We sat there comforting each other. Suddenly he was back. Mary was still coughing.

"She can't help it, Bob!"

"I'm not thinking about her," he yelled. "I came to tell you that I'm leaving. I'm not coming back, ever! I can't take it. I'm an artist; I have to be."

"Where are you going?" I asked.

"To Ocean Springs," he said. His eyes swept the contours of my stomach. He shuddered.

"I thought you knew I was pregnant," I said.

"You mean, don't you, that you didn't want me to know?"

He was gone again. Anger and a wave of self-pity swelled within me.

"I will never live with you again!" I screamed through the slam of the door.

The children and I sat there in the quiet. Billy was angry with his father, Mary was still sobbing, Leif cried because her daddy had left. I sat there rocking and rocking. At last exhausted, the children slept. They did not stir when I tucked them in.

The tears flowed down my cheeks; I was powerless to stop them. I went through the whole house, even the attic, his sanctuary. Outside, the night was clear and full of stars. His bicycle was gone.

At last I fell into bed. I was cold, inside and out. The tears would not stop.

The next day my sister came to tell me that Bob had arrived in Ocean Springs early in the morning on his bicycle. After a few days he came to Oldfields, very pale and strained, and collected a few things—the blocks for the prints, the molds for some pottery figures, very little else. Soon he evicted the people who were renting our cottage in Ocean Springs and moved into it, where he would live and paint and work for the rest of his life.

Now came a strange time. He would not live with me, but he could not stay away. It was fifteen miles between Ocean Springs and Oldfields; his bicycle was his means of locomotion. He never came during the day, but he would arrive at midnight to sleep a part of the night and depart before dawn. Most of the road covering that fifteen miles was Highway 90, two lanes, narrow and curving, and traffic was beginning to increase to hazardous proportions. The county highway patrolman, an old friend, informed my sister that he was worried. "We're going to pick him up in a basket," he said, "that's what's going to happen. You tell her she better move back to Ocean Springs."

It was not just that well-meant warning that made me

speak out one drafty midnight when Bob, in a sparkling state of love, arrived at Oldfields. "Why don't you come back?" I asked as he lay beside me, warm and dozing.

He was up on one elbow in a second. "Why should I?"

"Mary and Billy are unhappy," I replied. "Leif is desolate."

He rose and sat on the side of the bed.

"Besides, coming here on your bike in the night is dangerous. You might get killed."

"Oh, you make me tired," he said. "You with your children and your death on the highway. Don't you know what I want to hear? I want to hear you say that you can't live without me. But don't say it. It wouldn't make any difference."

He was very serious now, his eyes glittering even without light in the room. He went over to the fireplace and stirred up the coals. He took the two sticks of kindling and the backlog I had carefully put aside to warm the children in the morning when they dressed for school. In a few minutes the fire leaped up and the room was full of light and shadow.

I got out of bed and pulled the rocking chair to the fire. He sat in a chair, also facing the fire, his shoulders slightly hunched. He was clenching and unclenching his hands.

When he began to speak, it was as much to himself as to me. "You see," he said, "I can't do without you. But I have to. Listen to me. My heart is so torn. I know what I have to do. When your father talked to me a long time ago, I knew that marriage was wrong for us. You were so innocent, I loved you so, I wanted you so much." He had dropped to his knees, his head in my lap. "I've made you so miserable," he said. "I have no right to come like this in the night. Yet I must. I can't do without you. Will you let me continue to come?"

Through my tears I whispered, "I'll always be here for you, Bob. Always."

Then he was gone. I sat there before the fire a long time. I felt very young, like the beginning of the world.

Chapter Fourteen

The baby was born in March—a second little boy, Johnny, the image of his father. He was quick, intelligent, taking things as they came, with composure. His father admired him outrageously, but was very careful not to show it on the rare occasions when they met. The other children missed their father. We would go to Ocean Springs to see him, only to be greeted by shouts of displeasure. Though we never went in when he said "No," we knew that our being there broke his involvement with his work.

That year I applied for a job as a teacher in the Pascagoula school system. I was accepted, provided I agreed to go to summer school. My Radcliffe-Harvard transcript signified to the superintendent that since I had been to one of those Eastern finishing schools I needed some time at one of the good, old Mississippi normal schools. I was enrolled in a summer session of Mississippi Southern College's extension course to be held at the Pascagoula High School. I was not looking forward to it. I was still nursing Johnny. However, I had been able to arrange my classes so that I skipped only his two

o'clock afternoon feeding; he was content with a bottle. I was so shy that the idea of going out into the world filled me with apprehension and depression.

Mr. Yocum, our longtime friend and former overseer at Oldfields, helped me get the job. He was a school board member and knew what a dearth of teachers there was in busy Pascagoula, where the shipyards were working double shifts to replace torpedoed merchant vessels. All the workers seemed to have large families, so the schools, too, were on double shifts.

During the summer of 1947 I completed the necessary courses to qualify for a provisional license to teach in Mississippi and was assigned to teach second grade at South Elementary School in Pascagoula. I was to teach on the second, or afternoon, shift from noon until 6 o'clock. My father was deteriorating, physically and mentally, but Robert came in the mornings and stayed until six to take care of Daddy. Susie was taking care of the children. Harris and Mary Brister had moved into the old caretaker's cottage adjoining Oldfields.

Mary, too, had taken a job in the Pascagoula school system, and although we were assigned different schools we had the same shift and this gave me a ride and a companion. She was also teaching for the first time, so we trembled together during those terrible first days of September.

Shortly after school started we had real reason to tremble. It was dreadfully hot and the air was heavy. All of the old-timers in the area declared that it was our year for a hurricane. In the middle of one afternoon the principal came into the room and told us that the weatherman had just announced a hurricane alert. School was being dismissed early. "All teachers will remain on duty until all children have been picked up."

My mind raced ahead to Mary and Billy, riding the bus from the Gautier school; to Leif and Johnny, with Susie and Robert. How I wanted to fly home and be with them! Time crawled as the bus children were loaded and mothers arrived

122

to pick up their offspring. I could not see how they could possibly be so slow about it. We headed home. When the storm finally reached us, it was with such violence, such destruction, that those of us who survived it were to remember it the rest of our days.

With Susie and Robert's help, I did what I could to prepare for it, securing shutters and moving outdoor objects to shelter. That done, Robert left, for he had his own family and property to tend. My father prudently retired to his bed.

All night long, the wind blew and blew, the tide rose and rose. By four the next morning the full force of the hurricane was striking our little world, tearing at the boarded-up shutters, tossing the huge oaks' limbs, bending the tall pines almost double. As it wore on, the house-high waves were crashing against the bluff with such force that the ground in front of the house began disappearing in huge bites.

By nine it seemed inevitable that the bluff would go. I needed to warn Harris and Mary Brister in the cottage. I left the children with Susie and went out the back door and along the back fence, leaning against the wind, my breath blown from me, pelted by flying leaves and branches. Soon I became aware of two laden figures struggling toward me. Harris and Mary were coming to Oldfields. They carried as many of their possessions as they were able to handle. I remember the chest with their wedding silver and their little white dog.

Back at Oldfields, I did what I could to calm Mary Brister and cheer the children up by laughing and playing games with them. Leif, who was three, danced through the house, stopping when she reached the unprotected panels of the big hall doors to peer into the murk outside and squeal, "Over the b'uff we go!" The little dog followed her everywhere.

All day the great live oaks that stood in front of the house and along the bluff crashed to the beach below as the ground was swept from under them by the water, one by one. Each time one went, the house was shaken to its foundations; the vibrations of the many windows played a frightening dirge.

Inside, we watched apprehensively as the waters tore away more pieces of the bluff. The water was coming closer and closer to the house, particularly to the west end of the gallery.

Sometime after I managed to get lunch together and feed everybody, there was a lull in the storm, quite suddenly. The quiet was truly deafening. As it continued, Harris said, "I have a radio in my car. Do you think we could walk over there and see what has happened?"

We all wanted contact with the outside world. Had Shearwater survived? We traveled, the three of us, in a tight little group across the pastureland and into the ravine between Oldfields and our destination. Finding it a roiling flood, we had to go around the barn. When we reached the car in its shed, Harris turned on the motor, then the radio. The words came clear and distinct: "The center of the storm has struck Biloxi. It is believed that the loss of life is minimal. Damage has been concentrated in the business establishments on the strip of beach from Gulfport to Biloxi. All persons in exposed places take note. Do not return to your homes. This is the eye, the center of the storm. The other side will strike almost immediately with equal fury. Stay in your shelter. We repeat, stay in your shelter."

The wind was rising again. We scampered back to Oldfields where we sheltered quickly as the second assault came. The water was calmer and less destructive. The wind struck with a rather oblique rush, almost as if it were sparing the old house. By this time we had all become perhaps slightly more philosophical. We went into the pantry and made corned-beef hash, opened a jar of beans and a can of applesauce. Mary Brister made coffee and we gathered in the dining room and feasted.

The wind was still high, but it was obvious the worst was over. Mary and Harris decided to go home to spend the night, and set off before twilight was gone. At Oldfields, we lay listening to the slow and increasingly distant sound of the

surf until our wonderment merged into weariness and we slept.

When morning came, the winds were gone. Heaviness pushed upon us. Everyone longed to go back to sleep. By the time I finally rose and prepared breakfast, even Daddy was up and hungry. Harris reappeared. We all heard a persistent sound, not like wind, not like water. Ah, the bawling of cows!

"You'd better get out to the barn," Daddy said to Harris, "and get those cows milked. Never had a hired hand to eat before the stock." He sounded quite miffed.

When breakfast was over, we burst the shielding planks away, opened shutters and doors, and ventured out. We realized that the bawling we had heard was coming not from the barn but from the beach. We went down the bluff and were soon chased up again. Indeed, there were cows on the beach. Some were dead, some were caught in piles of debris. A few stood shakily, heads lowered; crazed by terror and the salt water, they apparently charged at any moving object as if it were the cause of their agony.

At first I thought they must have come in a roil of wind and water from Horn Island, but I didn't see how any of them could have lived through such a journey. Later I learned that a Pascagoula dairyman had pastured his dry cows on a small marsh island in one of the mouths of the Pascagoula River, which was much nearer. Even so, I do not see how any of them survived to reach our beach. They didn't survive for long; it was impossible to help those that were still alive. Eventually the Health Department took a hand and we were horrified by an open air cremation along the beach.

The aftermath of the storm was almost as difficult as the hurricane itself. Twisted piles of debris made it impossible to get around. Nothing functioned properly for days. Food spoiled. Gardens were destroyed. The hens didn't lay. The cows didn't give milk. Everyone resorted to canned food and such staples as potatoes.

By that first afternoon Robert, in truly heroic fashion, had fought his way in to see us. The highways were not yet cleared of fallen trees and power lines. Our road was flooded. I think he half expected to find that we had all washed away. He had brought ice, food, candles, kerosene, and the news that the family in Ocean Springs had suffered only minor damage. They were all well and recovering from the storm. For a few minutes after he left, I collapsed on the back steps in a fit of tears.

I was sitting there recovering when I heard a thrumming sound from the direction of the gates. Looking up, I saw a bicycle speeding down the littered road. It was swerving and leaping, almost flying through the air as it collided with tree trunks. It could have been ridden by only one person. It was Bob, exhilarated Bob!

He hugged me. "Oh, my darling, I'm so sorry, I'm so sorry!"

I wanted to melt into his arms like a piece of the crumbling bluff. Instead, I became as stiff as any poker. "Why?" I asked rather coldly.

"For not being here. For leaving you to face it all alone."

"I like to face things alone," I said. "I think I do it rather well." Then I went into the kitchen to save the scorching applesauce and to thrust the big iron skillet full of cornbread in the oven.

Bob entered the house like a returned prodigal fresh from far adventures. He swept the children up into his arms and twirled them like the mighty storm wind itself. Daddy shook hands as though he had forgotten the old enmities. The bitterness in my heart would not melt.

I put supper on the table, lighted some candles, and called them. All of them came swiftly and, it seemed to me, dancing. The food disappeared.

"Daddy, Daddy," cried Mary. "Come, now it's time to see the beach. The moon is full. Just wait until you see the new beach the storm has brought."

126

They vanished. I saw the progression of heads sinking below the level of the bluff, heard the shouts as they called to Harris and Mary Brister, who came down to join them.

I put away and washed up, oriented Daddy to bathroom and bed, nursed the drowsy baby. Down on the beach the moon was full, still low over the river mouth, throwing their dancing shadows, dark and enormous, up at me. How white the new deposit of sand looked, crescent shaped, the ruined pier sticking out in the middle. They were just below the bluff dancing what seemed to be a dance of Thanksgiving. I had an uncontrollable desire to leap among them like the storm itself. Instead, I came stumbling down and landed on the edge of the beach. They all came to a stop and looked at me.

Leif spoke as if to an interloper. "Mama, we were dancing," she wailed.

We all stood there for a bit in the moonlight. Harris began to tell Bob about the cows. The children ran. At last we drifted up to the house. It looked so beautiful in the clear cold moonlight that I began to cry. I cried all through the children's bedtime and could not meet their wondering eyes.

When I got to my room at last, Bob was there. He rose from the floor where he had been lying pressed against the screen door. He took me in his arms as if he were comforting a child. His words came right against my ear. "I love you, Sissy. But you still can't decide what comes first."

 Six months after the hurricane we had all left Oldfields. None of us were ever to live there again.

I had been teaching in Pascagoula for about six months when my father died. I had not realized how much I depended on him. He was eighty-six. Since 1932, he had suffered from arteriosclerosis. He

was *non compus mentis*, yet he was my protection and my anchor. Without him, I could not remain at Oldfields.

After the hurricane the house leaned dangerously near the bluff. All during the spring of 1948 my uneasiness grew and when fall came I applied for a job in Ocean Springs. I was accepted, and the children and I moved into a little rented house near my sister Pat and her family. Bob did not have to travel the increasingly busy highway to come to his wife in the night.

Certainly, our move to Ocean Springs made no appreciable difference in Bob's relationship with us as a family. As he had told me he must, he remained steady to his compulsion to create and, to all intents and purposes, was single. He was a painter always, a lover at times, a husband and father never. The children and I eventually moved into the Barn with Mère.

Alone at the cottage, Bob worked hard. It was never a chore for him to get up in the morning. He awoke early, put on his coffee, and jumped into a tub of cold water. There was no heat in the unsealed bathroom of his house, and on any one of our typical cold days the water was apt to turn to ice as he splashed. He ate perhaps two pieces of bread with his coffee, probably reading as he ate—reading and being as marvelously stimulated by what he read as though in conversation with a soulmate.

In the mornings he decorated pottery on the porch of the cottage. Rebel that he was, he was surprisingly careful to do what was right, and it was right to do, first, that for which he was being paid. Carelessly, upon the floor of the porch where he worked, mounted the piles of cigarette butts and the dust from the clay. He sang no more at this time; smoking had already destroyed his beautiful voice, but he hummed or whistled and was answered by a mockingbird in the Cherokee rose. His turtles and king snake rustled in the leaves for the crumbs he had thrown out for their breakfast. Perhaps some rescued duck or tame possum pattered about his feet

and, looking down, he twined their likeness into a plate. He knew anatomy so well that he could distort at will without changing the fundamental shape. He drew the design upon the dry, unfired clay, sometimes very lightly with a pencil, sometimes incising the line so that the surface was divided and the slip or underglaze, whichever he was using, was in the raised areas. Often he painted the whole pot with white slip and let his lines show through to the natural color of baked clay—a warm buff.

He devoted his afternoons to painting. He liked the northern light on the glass-enclosed section of the back porch. An old handmade bench had been acquired during some storm on Horn Island and he sat on one end of this, using the other end for paper, paints, and incidentals.

For a period he volunteered to teach art to patients at the Gulfport veterans hospital. It was during this time too that he began to do a lot of wood carving. At the northern end of his house he cleared a space in the woods and carved a tremendous male figure representing the Mississippi River. The group around it consisted of animals found along the river banks. All the small animals were beautifully carved from fallen logs and painted. The deer was the largest of the animals and is the only one still in existence. There were birds too: bluejays, cardinals, ducks, all perched in natural fashion; the carved flowers stood upon dowel stems of varying heights.

Sometimes he executed his work in a living tree if its form and growth pattern suggested something to him. He carved a wood nymph at the edge of a swamp in a twisted wax myrtle. He carved a boy climbing up a vine in a jack oak; later he turned the carving into a bird feeder. The largest of his carvings, nearly eight feet long, is a graceful swimmer that still exists, despite some of the ravages of nature.

He carved cats, squirrels, cows, birds, fairy-tale figures. Nearly all of the small ones were sold when he consented to a request by Memphis friends, Louise Lehman and Louise

Clark (director at Brooks Gallery, Memphis), that they be placed with his block prints in a show at Brooks in 1948. This show became a traveling show sponsored by the American Association of University Women. This exhibition, the only one of any importance held during his lifetime, was shown at the Brooklyn Museum of Art in 1949. He used the proceeds to go to Costa Rica.

He quit carving after that and began once more to devote most of his time to drawing and painting. He also began to take long bicycle trips. He pedaled to the east coast of Florida to see Frank Baisden, an old friend from the Pennsylvania Academy of the Arts. He bicycled to Philadelphia to see a show of the works of his favorite academy teacher, Henry Mc Carter. And he crossed Texas into Mexico.

As for me, even though I loved teaching school, the day-by-day contact with young and growing minds took its toll. I was tired all the time.

Bob used to come to me and murmur in my ear, "Sissy, wake up! Let's go for a moonlight swim."

I would struggle from sleep, take his hand, and walk to the beach down the sandy road. I would see the shine on the pine needles and the dance of the leaves because he was telling me to, but all the time I was thinking: The children may wake up, Mère may need something, I'll go to sleep in the reading group tomorrow. The chill of the water and the moonlit pathway were not enough to release me from my cares.

Several years went on thus. I was of so little good to Bob. I could say, equally, that he was of little use to me, for he was more and more absorbed in his own world, but it would not be true. The minutes here and there that we managed to spend together meant everything to me, but a serious problem began to be apparent. Often Bob started drinking beer with his lunch. Once started, he would drink fairly steadily all afternoon. Beer did not affect him as badly as hard liquor or quantities of wine. No one in Ocean Springs would sell

whiskey to him, but there were stores where he could pick up wine as easily as rice, and almost as cheaply.

His drinking was to lead to hospitalization again. A psychiatrist advised the family: "Don't coerce him. He has proved himself capable of living in his world. Don't push him in any way. Tensions build up when someone tries to force his behavior. Let him be."

We tried.

Chapter Fifteen

I always got an odd feeling when I arrived at the screen door of Bob's porch, full of some tale about the children, only to find a scraggly message pinned to the wire. "Gone to Horn Island" was the most frequent one.

"Gone to China" appeared not long after Aunt Dellie's death. Aunt Dellie was his mother's sister. She left each of her nephews a thousand dollars, and Bob wasted no time spending his. It was a trip he had longed for. He felt that China was the most advanced country in the world, intellectually, and that Tibet was the summit of all countries spiritually.

We had a postcard from California. It made no difference that he was expected at the Brooklyn Museum show. He was in an airport waiting for a plane. No word, then, for months and months. This was in 1949. China was full of revolution. Even on this coast, we heard rumors of recalled missionaries, of hardships, of dangers. We read news of Chiang Kai-shek and even Mao Tse-tung. I was getting restive enough to think about seeking help from the State Department when the

cable came: "Money and passport stolen. Send passage home."

It was sent from Hong Kong. We telephoned the American consul in New Orleans; he agreed to relay the money to the consulate in Hong Kong. Mère and I scrabbled about and together gathered enough for passage on a freighter. Back came another cable: "Must fly." Was he ill, maimed? I borrowed the extra money and off it went.

I had been told that when he left for New Orleans he was riding his ancient bike. A few days after I sent the money he returned the same way. It was late evening when he appeared at the Barn. My God, how worn he looked. How terribly thin he was. What would he say, back from the ends of the earth?

"Had a flat tire," he said casually.

Tomorrow he would talk. Today he ate three bowls of vegetable soup and went off to his house and his bed. The next day, after supper, he brought out a manuscript. "It's not the real log," he said. "They took that from me, along with all my paintings and drawings, the whole record of the trip. This is a recollection in tranquility. I did it while I was waiting in Hong Kong. These drawings, too."

The children climbed up on the stairs. It was their favorite place from which to listen to their father's tales. He began to read from the China log. In the first paragraph the plane he took lost a motor over the Pacific and had to return to San Francisco. Adventure was definitely in the air. In the final sentences the guerrillas invaded his camp while he slept and removed his knapsack, which held everything he owned.

"I dreamed that a water buffalo had hooked its horn through the strap," he said, "and, waking, leaped to my feet to pursue. There was nothing in sight all across the wide sweep of the rice paddies. I had lain on the side of the road, slightly raised above the plantings of rice. Now, as I stood trying to determine what had happened, the morning sun was

gilding the tops of mountains miles away in Tibet. I could see my goal. Much good it did me."

He had to decide what to do. He had no passport, no permit to pass into Tibet, no identification of any kind, not a cent, no food, in a country increasingly war-torn, suspicious, and alien. He stood and watched those golden mountaintops for a long time. After all, there was no reason for haste.

"I had decided that there was only one thing I could do. That was to retrace my steps, hoping eventually to get back to some place where a semblance of order remained. At least, I was comforted by the fact that I was in China. I would not go hungry. My experience had been that if you had no money to buy food, you just sat cross-legged, wherever you were, and held out your bowl. If you didn't have a bowl, your cupped hands would be filled as readily. It had been well rolled in my blanket, so I still had it."

Leif wanted to know what he did when he didn't like what was given him.

"I ate it anyway," he answered. "Ate it and was grateful. It seemed a long, long way walking back. Nothing looked familiar until I reached an old ruined temple where I had spent some time drawing the intricate ornamentation of the lintels. At the next fairly large town, someone led me to the home of some missionaries from America. They were loath to leave their converts, although fully aware of the situation in China. They gave me shelter for the night and sent me on my way to Chungking where, they said, I would be able to get a cargo plane out to Hong Kong. Within two weeks I was storming the doors of the American consulate. How far away it all seems now, and home—how beautiful!"

He got up and came to each of us and hugged us, hugs of thanksgiving.

After many years I saw the drawings from the China log again. They still had freshness and power. Despite his misadventures, Bob had felt kindred spirits all about him in

134

China—not just the man who put the circles on fans in the Chungking marketplace, but also the soaring souls of men who pressed triangles into the bricks of the road or chiseled lilies into the stones of temple revetments. I often wonder what happened to the paintings he did there, the fruit of his long hours of work. I see his mobile mouth, laboring as hard as his fingers, and I hear the strains of Beethoven lingering over the rice paddies and the dusty roads. I suppose the paintings have long since gone up in the smoke of a campfire or served to wrap a cut melon for some child.

Perhaps, though, some elderly Chinese, a lover of beauty, pasted it on the wall of a hut. Could it still be there, water-marked, smoke-blackened, adding its bit of color to the grayness?

 In 1950 the people of Ocean Springs were building a new Community Center. The architect, Mr. Lindsey, had told Bob about the plans and Bob offered to decorate its walls. Fred Moran, a supervisor and one of Bob's friends, used his influence to overcome the objections of some of the townspeople. He and a local service club supplied the paint. Bob was willing to execute a mural as a labor of love, as an artist's contribution to the community.

Bob became obsessed with it. He got out Gayarré's *History of Louisiana* and steeped himself in the period following Iberville's arrival on our shores. He bicycled to New Orleans to the Cabildo's archives. His conception of the mural was based on his belief that one must acknowledge the interdependence of all life.

"History," he told me, "is like a life in the midst of all

lives. It is the natural world that counts, primarily the universal world, the world of planets and climates."

He developed a plan for the mural. Down the length of one side of the hall, the landing of D'Iberville would be depicted. Down the length of the other side, he would paint the flora and fauna of the region.

He made sketches, drawings, and watercolors of the panels. He would have liked to use fresco; he would have liked to be joined by all the school children and adults interested in painting, but that did not happen. The contractors were unwilling to experiment on a suitable surface for fresco, and the people of the town did not really want their children working with the "mad artist." In the end, and surely for the best, he did it alone.

He began to experiment with paints. At first he tried to use a sort of gesso, but found that it ran so badly he had to clean up and repaint. He blocked in the design with a goldish color. Finally he worked in oils; on the rough cement walls they assumed a soft look almost equivalent to the fresco he had coveted. He worked hard on the project for more than a year. Once, he insisted that I come down and work with him. I tried. My work, painstaking and tight, trying to follow the lines of a tree's branches, was unacceptable to him, and I never tried again.

I can see him still as I saw him so many times on my way home from school, high on his ladder, his paints spread on the fold-out shelf at the back of it, his clothes a mass of daubs. Often people would be standing around him. They were generally amiable and interested, but sometimes they poked fun. He painted on. Guy Northrup, art critic for the Memphis *Commercial Appeal*, came down and spent hours with him. He was fascinated not only by the beauty of Bob's work but by the force of his intellect, the depth of his knowledge.

When the mural was finished at last, it took my breath away. In Ocean Springs, it was controversial. Many people were proud of the mural; many actively disliked it. A friend

of mine who had been elected to the Board of Aldermen was approached by one of her colleagues, who told her, "Now, I helped you to get elected. The first thing I want you to do is get me enough nice white paint to cover that crap in the Community House."

Fortunately, the request fell on deaf ears. Despite the inadvertent abuse in the years that followed, the mural is still there. Now treasured and cared for by the community, it attracts visitors from all over this country and many from abroad. They come to look and marvel.

 When Bob wanted to be with me at all, he wanted to be alone with me. Sometimes I dared to slip down to his house in the night. Our apartness was his necessity, not mine. I was not afraid of him any more. I did not feel that he was ill or irrational and I believed that it was I who had released him to be himself.

One night a little past full summer I walked as he had taught me, on the sides of my feet like an Indian, down the little path between the lush growth of summer green, with the brightness of the moonlight spilling over me. I reached the precarious steps to his sanctum, the old hatch stair he had salvaged on the island. I mounted it shakily and looked in, my nose against the torn screen of the porch where he slept. He was lying on his back, naked. His body, where the clothes had sheltered it from the sun, shone like samite. The door was hooked.

I backed down and moved to the back door of the house. All over the bushes behind the door, all over the fallen chinaberry tree, the moonflower vines had spread themselves and were covered with blossoms made whiter, more

luminous, by their faint lilac cast and exuding a poignant sweetness. The old cottage was a bower. I climbed the steps there and went through the door and out onto the front porch.

He had not moved, but he spoke. "I made you come. The force of my desire reached you."

He pulled me down. Some time later, he asked me to come into the house. "They say that if you lie like this in the light of the full moon you will awake a lunatic," he said. "It doesn't matter about me, but I would hate to have you fall from grace. Besides, I want to show you something."

There were seven watercolors spread out on the table. They were all of birds, Horn Island birds: grackles with tails caught in a gust of wind; tree swallows in a pattern of hungry feeding in flight; hummingbirds suspended in a thistle field in pure evening light; black skimmers in a pattern against another pattern of wave and sandbar, their long lower mandibles thrust urgently just under the shallow water; coots cruising the lagoons, awkward and amusing; mallards, some tipping up for duckweed; drakes bobbing about, watchful, preening their brilliant speculums; hens asleep near the bullrushes; a raft of redheads, playful in the frigid whitecaps of a bright, cold day in full winter.

My heart was shocked with joy. Small golden hairs were standing straight up on my arms.

"What do you think?" he croaked.

I showed him my arms. He ran his fingers down them with delight.

"You have been looking for the Garden of Eden. You've found it, haven't you?" I said.

The strain was gone from his voice. He was very serious. "Yes." Then, "I've had very good training, you know. I've studied and profited from all of art history. I think few people are better qualified to paint the appearance of things than I. Yet, that is not really what I want. The heart is the thing that

counts, the mingling of my heart with the heart of the wild bird: to become one with the thing I see."

I went away hardly hearing the question he flung after me. "What did you do with my jug of wine?"

One evening I heard the crash and tinkle of glass breaking. Had Bob's habit of easing tensions by smashing out his windowpanes resurfaced? He had seemed to be in good shape. He told me that he had given up alcohol. "I am convinced that, next to water, fruit juices are the only thing fit for the consumption of the gods."

Tobacco, too, had been briefly banished. Yes, he seemed definitely in a shining state. Now, my feet felt like lead as I made myself go down the path to the cottage. How badly had he cut himself this time? He was sitting slumped on the bed, without a shirt. The shirt was wrapped around his left hand. There was a good deal of blood.

"Bob, what have you done to yourself?" I asked.

He made a foolish little sound. "Not a thing. The window hit me." He unwound the shirt. The bleeding had already stopped. The scrapes and scratches were superficial, but the fist was swelling. I sat beside him on the bed and realized at once that the "fruit juice" had been fermented. He dropped backwards onto the bed, kicking his legs into the air so that they passed over my head; he rolled on his side and went to sleep. I went back to the Barn and returned with Merthiolate and dressings. It was easy to bandage his hand; he did not stir. "Why? Why?" I asked myself.

The next day, when I came home from school, he came

to get me. "Thank you for bandaging my hand," he said. "I'd just had a shock. I found out that Einstein was dead. My world could never be built on equations, and I don't think his really was either. He sought so desperately for the unifying factor. He made such voyages among the galaxies. I felt a real kinship with him. When I heard he was dead, I got on my bike and went riding. On the way back I stopped and bought a jug of wine. Please forgive me."

"There's nothing to forgive," I told him. "I love to see you shine, and you are shining now."

He took me in his arms. "Sometimes," he said, "you are very good for me."

Later he talked about it again. "I have the greatest respect for those who seek out answers to deep, fundamental questions. Where did we come from? Where are we going? How was our universe brought into existence? How will it end? But I am a creature of senses. I can only postulate my answers on what they tell me. The strange thing is that they tell me the same things Einstein's equations told him."

He hesitated a moment. Did he expect me to say something? I had nothing to say. He went on. "$E = mc^2$ is the same thing. Don't you see?"

Still, I had nothing to say. That equation meant atomic bomb to me and was something I refused to think about at all.

"It means," he said, a little tired, "that everything is one."

Chapter Sixteen

In the summer of 1954 I had a hysterectomy. It was routine surgery, but a sudden drop in blood pressure required emergency procedures to restore me. It took a long time for me to recover. Bob reacted with growing agitation. When I got home, Mère outdid herself taking care of me. However, after a few days we had to put her to bed with one of her wretched migraine headaches.

"Call Bobby," she said, "he'll know what to do."

Bob always came to sit by her, hold her hand, soothe her head with a scented cloth, hold the basin for her. This day, for some reason, I hesitated to call him. The children were gone about their various businesses and none would be back until evening.

"Call Bobby, please!" Mère pleaded.

I went out the front door, calling as I went.

Bob heard me before I got to his house. "What do you want?" he called without coming out. His voice reflected his annoyance.

"Your mother has one of her headaches. She wants you."

He came rapidly out and brushed by me on the path. I smelled the cheap wine as he passed; he had been drinking and was very tense. I sat down abruptly on the edge of the path. I had not realized how weak I still was. It took me a few minutes to recover. When I reached the Barn, I heard his voice, a frightening voice, coming from Mère's room. It was unnaturally controlled and icy with anger. By the time I ran into the room, he was raining blows on her face. I heard him hissing through his teeth, "This is one headache I am really going to cure . . ."

"Bob, stop that! You're hurting your mother."

I was trying to pull him off. I succeeded only because he turned on me. He crashed his fist into my mouth, shoved and pushed me out of the room, knocked me down, and closed the door, locking it.

I dragged myself to the front door, screaming for help. Blood was pouring from my lip; my head was buzzing. I was shaking with terror.

His brother Mac arrived immediately. "I've called Peter," he said as he rushed by me. He put his shoulder to the bedroom door. Peter came through the front door, picking up the heavy poker by the fireplace, and he went to join Mac.

The bedroom door crashed open. Bob looked at his furious brothers. "I am helping Mother with her headache," he said.

Peter brought the poker down and Bob slumped against the doorjamb. They put their shoulders under his arms, dragged him out to the couch, and dumped him. Mac called the doctor while Peter stood guard, poker in hand. "If you move, so help me God I'll kill you," he told Bob.

Bob moved so fast no one could have believed it. He rolled off the couch, threw his arms around Peter's legs, and had him down in seconds. There was an all-out fight in the middle of the floor before they rolled apart.

Dr. Frank came in the door, his needle ready. He drove it in without protest from Bob. "Just a sedative, Bob," he said

142

quietly. "Mac will walk you home." He turned to me. "I thought I told you to stay in bed. Go lie down." Then, "Let's have a look at your mother, Peter."

He was with her a long time. He bathed and dressed the lacerations the best he could, soothed her, and administered a sleeping tablet. Then he stopped by to see me. "Are you all right?" he said gently. He took a look at my incisions, cleaned my cut lip.

"I'm fine. What about Mère?"

"She's fine, too, but I don't know why. She looks a mess, but she says her headache is gone!" His smile was lovely. I tried to reciprocate.

After a while my sister Pat came in. "He has to go to a hospital," she said.

"I know," I said. "But it has to be temporary, and he must know it. It's the tension of my being sick; it's the drinking. Can't he go to DePaul's this time? Please!"

And so he was taken away, unconscious, by the police. Mère also went to New Orleans, but to stay with relatives until her black eyes and bruises healed. She refused to be seen; people might infer what had happened. I think she was still saying, if only to herself, "Bobby is Bobby."

Very early in our life together I had realized how dependent Bob was upon his mother. It was not just that he was her favorite child; it was far more complicated than that. She was an artist, he was an artist. Similar interests, similar temperaments drew them together. They were isolated, for all practical purposes, from professionals who were artists. They needed each other for criticism, for discussion in their own language. He loved her deeply; he respected her even more. Over and over she had demonstrated her faith in him. In my moments of doubting him throughout our marriage, it meant a great deal to me.

During the last years of her life Mère began to feel a weakness, and to awaken in the night disoriented. Bob, who hated telephones, had one installed so that she could call him

when she needed him. After her ninety-sixth birthday she developed pneumonia and Dr. Frank took her to the hospital. She was under an oxygen tent, in a coma, and all of us took turns staying with her. Bob and I always went together. He did not want to be alone as she lay dying, and I feared his reaction to her death when it came. When we were there with her, he pulled out his clipboard and drew her endlessly.

The Saturday of her death Bob sat against the wall at the foot of the bed drawing her. I sat close beside her, holding her hand. Suddenly she gave a small, smiling sigh and was gone. I looked at him, apprehensive. All of us had speculated about what her loss would do to him. He was completely absorbed in his drawing; his mouth moved, a half-uttered theme came from his lips. Then he looked up and saw me in tears.

"What is it?" he asked, and answered himself. "She's gone." He got up and came over to the bed. I gave him the hand I was holding. He dropped it on the sheet.

"Good-bye, Old Lady," he said and turned away. I had never heard him call her that before.

Bob stayed for her funeral and then headed out to Horn Island.

Years later I found a packet of letters that Bob's father had written to Mère. They all began: "My dear Old Lady." Bob's good-bye had been an appropriate one.

 Bob began to spend more and more time on Horn Island. The intensity of his life at home increased proportionately: increased drinking, increased smoking, and ceaseless painting with intensity that didn't seem

possible. He remained in port only long enough to do a weekly stint of ten pieces of decoration for Shearwater Pottery, which gave him his living. Then he left for three or more weeks on Horn Island.

I often wondered what he felt when he left for his island. Sometimes I had a strong feeling that he was tearing himself away from all that he had of softness and security. Sometimes I felt that he was fleeing Hell for Paradise.

I wept over departures made during winter's Nor'wester that blew the water out of the bay. Pushing the heavily loaded boat through deep mud seemed more than any man could accomplish; the wet, frigid trip in a rowboat across twelve miles of open sea, too great an ordeal. When he reached his island, there was no welcome, no host to pull him into warmth and restore his body with hot food and drink.

When I spoke to him of my feelings, he laughed. "It's the very weather for the trip," he said. "Pushing the boat out is like pushing a sleigh over smooth ice. I hardly have to row going out. The wind is at the stern, pushing all the way. The spray is like jewels for my delight. When I reach the island, the world is swept as clean as if Providence had just tossed it into place and I am the first man. It's bliss."

"But the cold . . . and no way to get warm and dry!" I cried.

"Cold is relative," he said. "By the time I've unloaded, pulled the boat to the shelter of my dune, and turned it over, I'm warm. Of course, not dry, for I always get wet unloading. There's such a surf on the inside beach from the north wind. But gathering wood keeps me warm and a fire soon starts the drying process. I dance. I take off every stitch and leap and stamp around the flames. My shadow keeps me company, blue on the sparkling sand. Then I put on dry clothes."

I interrupted. "They can't be dry after that crossing."

"If they were damp the flames have dried and warmed them and they feel wonderful. I sit close to my fire and drink coffee and eat hot soup. I have entered upon my kingdom.

145

When I roll in my blanket under the boat and feel the warmth still emanating from ash and heated sand, it's as if I feel the fire of a distant star. The air is so pure. No sound of siren or motor mars the music of the spheres. I think I'll go right back." He laughed out his joy and grabbed me in his arms.

How were those years spent on that island? Lonely, perhaps, but he never drank or smoked there. All the loneliness was swept away by the experience of painting, by the experiences that caused him to paint: some sudden sharing of a mood of nature, some appeal to sight or hearing. Above all, some appeal to his heart. His doubt lay only in whether those experiences could be shared.

How did he work? First of all, he sketched everything that offered itself to his eye. I think he stopped frequently on his walks to record the things he saw. Sometimes, back at his camp, he painted from the sketches he had made, but more often he carried his things with him and painted on the spot. I think he did this because he was so tremendously sensitive to the least differences in light.

Horn Island is a spot where light seems to be so intensified that it is almost unbearable. The sun streams down and its rays bounce back, reflected from water or white sand. Bob had a big umbrella that protected him somewhat when he was working, and often he worked in patches of shade, for the island is quite wooded in spots. The luxury of a tent or studio was not his, nor did he care.

In his logs he speaks of "going home" to his camp. He had chosen a beautiful spot outside the limits of the wildlife refuge on private land. Horn Island is crescent-shaped. The most curved part, known as the Horseshoe, is nearer the eastern end, and his spot was in the east curve of the Horseshoe. There are many high dunes, topped with scrub pines and often dense thickets of palmetto and bushes of rosemary. In the fall the island is brighter than ever with growths of dwarf goldenrod. In the spring clumps of cactus lift their yellow flowers like reflections of the sun.

He camped on the inner beach. His method of making camp was simple and effective. He pulled his boat as far up as the tide would let him, unloaded it, turned it over, and made his blanket bed beneath. He covered the bed with a mosquito net and the boat with a tarpaulin. Sometimes, when it was very cold, he built up sand around it and, once inside, was, as he said, "as snug as a bug in a rug." Creature comforts meant nothing to him. Inside, he had enough headroom to sit up. He could eat and work in his cramped castle, what more did he want?

Outside, the camp was neat. The big umbrella was like a porch. His food, in gunnysacks, was hung in a tree. His perishables, mostly paper and paints—perhaps a book or two, some matches, salt, sugar, rice, coffee—were in garbage cans with tight lids. He considered himself a sybarite, living in perfect comfort. Seldom did he mention the insects that plagued him, or the animals, from mouse to pig, that waged war with him for his food—the scarcest thing on the island.

He told me that he was greatly hampered on one trip. He had removed his tubes of paint from his hatband—he wore the most disgraceful old felt hats—and laid them on a board. He was painting small green rainfrogs in a setting of bullrushes. He said that either the frogs or the bullrushes had been made exactly the right size so that the frog was completely hidden except for his eyes and his small clinging hands. While he was painting, patiently circling the rushes at intervals, a friend came up, grunted a greeting, and lay down in the damp at the edge of the lagoon. It was an old sow who lived on the island raising, year after year, numerous progeny whose small, staccato footprints delighted him but whose boon to him lay in the network of paths she had made through thick places.

He had not really noticed her presence. This day, painting absorbed him, body and soul. When an alien sound finally came into his consciousness, it was too late. His friend and benefactress was munching his only tube of emerald

green. He was glad that no weapon was handy, for he would have committed mayhem upon her comfortable person. As it was, he was forced to do six rapid watercolors of small hylas and bullrushes with the rapidly drying drips from the tube of green paint and the mouth of mama pig. Outraged at the commotion, she departed to the other side of the lagoon where she lay in the shade, her small, round reddish eye, unblinking, accusing, upon him while he worked.

The whole world of the barrier islands fascinated him. Those white spines of land that separate the Mississippi Sound from the Gulf of Mexico—what winds, what currents built them up? The deaths of how many animals, how many vegetables allowed the slow growth? What birds or waves deposited the seeds of trees, of grasses, or sea oats? And how did the creatures—raccoons, bunnies, muskrats, nutrias, mice—make their fabulous journeys? All the questions, all the answers gave him much joy.

"I found the purple hairstreak on Horn Island," he told me of the butterflies, "but I have yet to penetrate their mystery, where they come from, where they go. Perhaps they actually hatch out there, but I don't think so. I don't know what the eggs look like, nor the caterpillars. I don't know whether they hang their chrysalis on a stem or bury it in the ground. I can only watch and wait and someday it will be revealed. That," he proclaimed, with utmost quiet, utmost secrecy, "is the most wonderful moment in all the world, when the secret is revealed. I have had more than my share of revealed mysteries."

As long as he was on Horn Island he was in tune with the rhythms of the universe. He was a part of the changing seasons. He was filled with the ecstasy of creation. He recorded it all, working endlessly. It became his world.

We lived in ours as best we could, from day to day.

Chapter Seventeen

Oh, the times when I woke in the night, my heart pounding, my mouth dry, with such a tightness in my throat I had to get up in order to breathe. I would leave the sleeping house and stand in the road, looking up through the leaves to find the stars that were shining on Bob at Horn Island. I would walk the path to his house to see if by chance he had come home. Over and over I would repeat my petition for his safety: "God in Bob, God through Bob, God over Bob."

Back in bed, I would tell myself that fear was to be feared, not reality. I would sleep, restlessly. In the mornings I wanted to tell someone that Bob had been in danger, but I knew it would be foolish and presumptuous. How did I know? How could I say that the heart line stretched as strongly as a monofilament line, as strongly as waves of sound and light that we accept as a part of everyday living? Why do we accept these minor miracles and reject communications of the mind?

More than once, when Bob finally came home from the island, he confirmed that my fear had a justification. His small

boat was vulnerable to weather and sea and larger vessels, but I think he was beginning to think of himself as the darling of the gods, at least on the island. In fact, I believe he felt that the Lord was quite ready and able to raise up an island for him at the proper time.

One of his capsizings occurred at the west end of Horn Island where a combination of tide and wind often caused a dangerous undertow. He was a strong swimmer and a man of quick accurate judgments, but this time he elected to swim for the distant shore rather than try to overtake his boat. He was tossed and whirled by the turbulent water. Swimming with all his strength, he realized that he was not going to make it. He relaxed then, and as he let himself go, his feet touched bottom. He landed on a new spit, as narrow as a needle.

Another time, in a heavy squall, he capsized off Belle-fontaine Point. A shrimp boat picked him up, rescued his boat, and returned to its trawling. In the first haul, along with the shrimp, they pulled in his trousers. Subsequent trawls fished up all his possessions except a copy of the Collected Poems of William Butler Yeats. "I just couldn't ask them to trawl again," he said. "Their wells were running over and I've often pictured the fish enjoying my book."

One winter day I was called from my classroom to come to Keesler Medical Center. Bob had been brought there by helicopter. His little boat had been swamped by a tug the night before, and he had spent six hours in icy water before being rescued by a Pascagoula shrimp boat. When he was first spotted at dawn through the mist, the captain shouted, "Will you come aboard?" The reply came back. "No, thank you, I'll make it to North Key."

Bob was swimming, pushing the boat before him. He had already been in the water six hours and was probably at least twelve miles from his destination. The captain of the shrimp boat managed to persuade him to come aboard with

a promise to rescue Bob's boat. The crew bundled him in a blanket and rushed him below to the warmth of the engine room. He was in his fifties at the time and exhaustion had taken a toll. The captain notified the Coast Guard and a helicopter was sent out to pick him up. Bob was furious later to learn that the shrimpers had to leave his drifting boat.

One late spring night when I was lying in his arms he said, "I very nearly drowned this time." Then he told me how it happened. He had been gone all day from his camp. When he started his walk down the outside beach, he planned to go to Rabbit Springs, pick up the jars cached there, fill them with water, and go back to camp. But it was a beautiful day and far down the island he saw thousands of seabirds hovering, so he didn't stop at Rabbit Springs. He was lured on and on.

"It was skimmers over the whole west end of the island and they were in every stage of nesting. I stayed all day. I drew and drew and drew. Sometimes I decide that the skimmer must be the most beautiful of birds: color, form, manner of flight, everything is there. The sun was fearfully hot. The stinging flies were dreadful. I had no food and, worse, no water. When the sun got so low that it was directly in my eyes and I couldn't see to draw, I turned my back on the whole of heaven and started home."

But he had a painful sore on his foot. He was so dry, and starved, and in pain, he limped down the front beach. There was a fair wind and the rollers were high. The low sun put rainbows in the spray. He couldn't go very fast, looking and limping, and when dark came he was still far from camp and tired. The temptation to refresh himself with a dip in the surf was too much.

"Just thinking about the water precipitated me into the waves," he said. "I swam straight out, unthinking, until the sudden feel of an undertow. Of course, I turned back at once, but it was too late. I made no progress. I turned on my back

to rest; the stars were far away. The tide was racing full out along the island's shore, and I was being carried east toward the Pascagoula channel.

"Then I remembered the point of sand that seemed to project just before the high dunes. Perhaps I could get close enough to touch the sandbar. I floated, lifting my head to watch my progress. I reached a point fairly close in, but I had begun to feel very heavy, very cold. It was time to swim. At first I swam strongly without panic, putting my feet down now and then to feel for the sandbar. My progress was not noticable. I began to churn and thrash."

Bob had almost given up when his sore foot gave a terrible throb of pain. It had hit the bar; he was saved.

"I knelt on the sand, and my head was still above water. Providence received my thanks and I dragged myself to the beach, coughing salt water and recovering my strength. Fate had a final twist; the mosquitoes landed as I dragged myself through the crossing. In camp at last, I drank all the water left in my jug and fell gratefully into my blanket and slept."

Now he slept again, this time heavily upon my shoulder. I was awake, certain he had told me of a night when I had waked in fright and been propelled all the way to the beach to look across the water and make my petition.

After another trip to Horn Island he lay beside me, taut as a spring. I was relaxed and wanted to sleep. When he began to talk, I could feel myself tensing, becoming as wakeful as he. "I wish I could tell you what it's like," he said. "It's the images. Oh, God, it's like desire, like a passion, like a fire. Nothing can stop it. I have to paint it, translate it."

"Tell me what you saw," I murmured. He had been back from the island only a day.

"The yuccas!" burst from him in a kind of agony. "They were blooming all along the dunes of the inner beach. In the night they are like white lights in the shine of the moon; in the day they are marble banquet halls tinged with green and

overflowing with feasting insects, invited guests, quite at home with the bounty.

"It began to rain just as I started drawing. It didn't stop. I waited. I tried to work under a blanket; I had forgotten the umbrella. In the morning when I went back it was over. The blossoms had faded. I felt like Caesar, stabbed by his dearest friend."

"Darling, you can do them next year."

"There won't be a next year," he said. "Such a blossoming is rare, and doubly rare on Horn Island where all the cycles depend on certain conditions which are unpredictable. My chance is gone." He turned with his face to the wall.

After other trips he had sadder stories to tell, like the one about the rabbit he called Split-Ear. "You remember?" he said.

"Yes, of course. He's the rabbit who greets you and sometimes eats at your rice board."

Bob's face bore the hurt expression of a child who cannot understand senseless, willful cruelty. "He won't anymore. They killed him."

"Who are they?" I asked.

"I never told you about them because I was afraid you and Mother would worry. You think of me as being out there on the island alone, in danger from storms and wild creatures—beasts, not humans. You're right in a way, for there have been so few people who have ever wished me any harm. Why should they? That's what I can't understand. They think I'm crazy, but mostly they let me alone."

There was a bunch who came out from Gulfport, he said, a big man and his sons. They were after flounders. "I used to watch them walk along the beach because the lights and the silhouettes were so beautiful. They waved sometimes. Then they got a boat with a light, too bright, in the bow. I didn't watch anymore. I just went to bed under my boat." He shook his head, puzzled. "Why should that make them angry? They

would come to my boat and beat on the bottom of it. The assault on my ears was so painful that sometimes I was unable to move. They kept it up one night until I reeled out, ready to fight the world." He smiled. "After I knocked the big man from Gulfport down, they let me alone."

I did not talk, because I realized he was having difficulty telling the story.

When the weather got cold, Bob said, the rabbit hunters came. Some of them were from Ocean Springs, including our son Billy. Those groups never bothered him. "We had a mutual tolerance; perhaps it was because of Billy. I'm sure they thought of me as harmless; I know I recognized the fact that they were performing a necessary service. There is so little food on the island and the poor little bunnies multiply at such a rate."

Soon groups from Pascagoula came. "Perhaps it was only one group. At any rate, they took joy in tormenting me. They employed the same tactic of beating on my boat, running and jeering when I came out after them. I tried to tell myself they had no idea what they were doing, that the funny old crazy man was sort of a challenge, that they were just mischievous youngsters. But when this happened . . ." He paused. I knew he did not really want to tell the story, but was compelled to.

"Split-Ear was really quite special with the kind of courage that belongs to great leaders. I have no way of knowing how his ear got split—the severed halves hung like limp flags–but the other ear made up for it. The minute we met I recognized him for what he was and greeted him with the sensible salutation he deserved. 'Come have a bite, old boy. It'll be ready shortly.' I remember I dusted off my board and

154

put out a piece of bread. He hopped right up and tried it. I gave him the core of my apple; he ate as if it were his due. Then he disappeared among the rosemary bushes, kicking up his heels in a bit of a 'thank-you.' "

When Bob gave the birds their morning rice the next day, there he was again, eating the cold boiled rice right along with them. "He has been my companion during all my sojourns since then." Bob sighed. "But they shot him." His head went down into his hands momentarily. "Then, to make sure I knew, they flung him into my camp. Poor Split-Ear! I buried him on top of the dune. I'll miss him." Bob's voice trembled. "Why do people do such things?"

"Because," I said slowly, "there are very few people in the world like you, because you are one with creation. You partake of it. It is a very wonderful but very painful gift."

I took him in my arms and groaned inwardly. Why couldn't he be like other men? Then I began thinking of all that would be missing from the world, all the beauty, the wonder, if he were. I remembered that I loved him as he was.

On one of Bob's trips to Horn Island he was bitten by a moccasin. "I was a fool," he told me later, "I know better. I suppose I was tired. I had walked over to the Gulf beach side of the island from my camp, passing by the mouth of the Little Bayou and coming out at the high dunes. It was such a spring day I walked fast, close to the water, all the way to the west point and back by the north beach." When he reached the oyster lagoon, the tide was up and he had to swim to cross the mouth of it. A nest in a little bush back in the marsh caught his eye and he sloshed back to investigate.

"It was too high for me to see into it, and I did something I never do," he said. "I reached up to feel into it, thinking about eggs or baby birds. I was pierced immediately as with the sharp point of a knife. It was a dreadful shock. Out of the nest came a startled moccasin. We looked at each other as if to say, 'How could you do this to me?' He let me go away, I let him go. It was as if there were no recriminations, just recognition of mutual fault."

Bob said the pain and shock were so severe he began to shake, then to vomit. He had to sit down. He looked at his finger where the fang had gone in. The mark was barely visible in the swelling that had begun. He knew he had to get back to camp to make a cut in the bite and draw the poison.

"It was about three miles to camp," he said. "I think it took me a long time to get there and, when I fumbled in my sack, I found only a dull table knife I used for spreading peanut butter. My finger had turned to stone. I decided to soften it in hot water, and built a fire for heating the water. I built it against an old drift log out of the wind, and promptly passed out."

When he came to, the fire had spread into the dry grass. "It was almost full dark. I dragged myself up, broke off a small pine, and began to beat at the flames. I think I fought that fire all night. Sometimes I would fall and lie half-conscious, just out of the reach of the flames. The fire got into the little grove of pines behind the camp; it spread into the marsh around the lily pond. It seemed to be devouring the island, and it was all my fault. I wept and howled and was powerless to save a single tree, a single little bird or bunny."

Bob was barely conscious for most of that long Saturday. He was sure there would be boats out because it was the weekend, but he had not reckoned on the wind. During the night it changed from the north to the south and blew the flames back on themselves. There was nothing more to consume, and when he woke up Sunday morning the fire was

over. A man and woman were walking on the beach below his camp. He shouted, struggled to his feet. They seemed to neither see nor hear. He pursued them.

"I'm in trouble. I've been bitten by a snake. Will you take me in?"

"I can't go in," said the man. "The wind is too strong for my boat. I'll take you when it goes down."

"I fell almost at his feet," Bob said. "He kept walking down the beach. When I regained consciousness, his boat was gone. I saw two boys fishing off the barge. I went down the beach, making wild signals to them. What wonderful boys they were! They came immediately and lifted me into the boat. They took me to Pascagoula, put me in their truck, and brought me to you."

"Yes, I'll never forget," I said. I was just starting out for church when those boys lifted him out of their truck. This dead man. I was sure Bob was dead.

"He said he was snakebit," one of the boys offered.

A croak came from Bob. "Take me to the doctor."

"Put him in that car," I cried. I leaped into the house and to the telephone. Luck was with me. I got Dr. Frank at his house, just home from Mass.

The two of us managed to drag him through the back door of the doctor's office and onto the table.

"Bob, can you tell me when this happened?" The doctor's voice, with its note of confidence, seemed to revive him. His eyes opened, he licked his swollen lips; he summoned a hidden strength. "I think it was Friday afternoon," he said.

The doctor turned to me. "He's going to be all right," he said. "It's too late for serum; it would just make him sicker. He has battled it with his own strength and resistance. I'm going to give him something for the pain and an injection for the swelling. Also, a good big shot of an antibiotic. Can he take penicillin?"

"Yes, I can," croaked the patient. "I feel better," he added.

"Typical reaction to the presence of the doctor," laughed Dr. Frank.

"Do you know why you're alive today?" he asked Bob as he jabbed home the first needle. "I believe it's because one of that snake's fangs slipped between your fingers and you only got half the venom. There's only one puncture."

"I thought about *Green Mansions* and old Nuflo," Bob said, "and I stayed as active as he did. I fought a fire all night."

The doctor shook his head. "No, that's a mistaken view. The more active you are, the more the blood circulates and carries the poison throughout your body. That's probably why you're so swollen all over."

"Would it have been better if I had cut the place and sucked out the poison?"

"Not with your lips in the state they're in. It might have killed you."

"The fire started because I tried to get hot water to soak the wound."

"It's a good thing you didn't. That too would have increased circulation."

I heard Bob murmur something about Providence being on his side.

"Stay in bed. Try to take lots of liquids. A good hot bath might make you feel better, but . . ." The doctor turned to me, "You stay with him while he takes it."

Bob submitted to being coddled during the few days of his extreme weakness. Mère and I enjoyed our brief days of administering baths and juices and rubs. As soon as his strength returned, he was off to his own house and off to the island again before a month was up.

Later I heard the joke that went around Ocean Springs. It was that Bob Anderson had gotten bitten by a moccasin on Horn Island and survived; the miracle was that the snake lived, too.

Chapter Eighteen

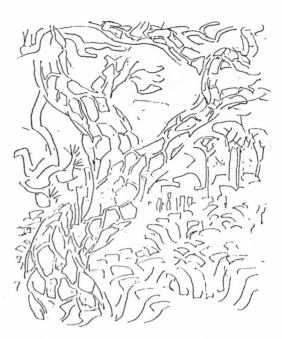

Bob had been on Horn Island six days in the fall of 1965 when we were alerted that Hurricane Betsy was in the Gulf. I called the Coast Guard in Pascagoula and told them that he was on the island. The rescue mission was unsuccessful. Their boat ran back and forth in front of his camp, but Bob did not appear. I could imagine him peering from some leafy refuge in a myrtle thicket and laughing at the heaving cutter and its seasick crew.

The storm swirled along the Mississippi coast and hit with full force in New Orleans. The next morning, after we listened to accounts of devastation, I asked one of the Keesler pilots who flew hurricane watch to fly over Horn Island and see if he could see anyone. On his return he assured me that there was indeed a man walking along the Gulf beach with an easel over his shoulder. I laughed with relief. Bob never used an easel on Horn Island, but who else would that be?

The days dragged along unbearably hot and sultry. Leif was within two months of her baby's birth and staying with

me. The first week ticked away. At last, from next door Pat called out, "Bob's back. He's fine." I rushed over.

"I had to check the island," Bob said. "It took a long time. Everything is horribly changed. My dune, my shelter for years, is gone, vanished. Nothing is left. The beaches are piled up with decayed marsh grass from Louisiana and tons of debris—it looks like a great housecleaning took place in Louisiana and was swept onto Horn Island. There were lots of casualties. The first one I found was my old sow."

"Oh, Bob, I'm sorry," I told him.

"All the little creatures suffered, but the miracle seems that there are plenty left to carry on." He turned and went back into his house. I was dismissed.

The next morning he left early by bus for New Orleans to see Nash Roberts, the meteorologist. He explained, "I think I've discovered something important about hurricanes."

He came back from New Orleans laden with charts and projections and worked for most of that month on a theory of hurricanes and on his pottery. He had to make up for time lost in his decorating work for Shearwater.

When I next braved him in his den, he came out to talk. "Bob, had you known the hurricane was coming?" I asked.

He told me that on that Friday there had been a disturbing sunrise. "No one could miss the warning. All day the wind was rising and there was surf on both sides of the island. I moved to a high dune to sleep, and chose a tree to tie to if the water kept on rising. I woke up and saw that the tide was rising fast. I waded farther into the island, pulling my boat behind me. Sometimes the water was up to my chest. I kept moving until I found a sheltered spot in the dunes facing the Gulf. The wind was blowing hard by then. I turned my boat over and settled under it. That's where I spent the hurricane."

I had nothing to say. No admonitions.

"I'm going back to New Orleans tomorrow," he contin-

ued. "I'm missing a very important clue. Did you ever notice how after a storm, weather drops down on us heavy and hot and smelly? I think there's very little doubt that these winds hold, suspended above their fury, part of the atmosphere that has bred them. I need more charts."

After the second visit to New Orleans, Bob told me about his night on the Mississippi River levee. He always camped there at the end of Broadway, near Audubon Park.

"I lay in the tall grass," he said, "in a jumble of wind-borne storm debris. When I sat up and began to eat my bread, I became aware of a presence there with me. I scrutinized the tangles of grass and presently I saw a beady eye staring from a clump. I waited for the creature to come forth and when the head appeared it was covered in some of the most brilliant colors I have ever seen—electric blue, green, gold, red, and black. And it wore a tall crown. It was some kind of exotic pheasant. Other creatures came out, and I began to realize that the bird collection from the Audubon Zoo had escaped to the levee. I tossed out a crumb. They were starving, poor creatures."

Bob walked to the zoo and reported his discovery. "What appeared to be freedom might have become tragedy," he said.

Six weeks after the hurricane, in November 1965, he came to see me and asked that I take him to the doctor.

"What is it, Bob?" I asked him. "Dr. Frank won't be in his office on a Sunday. I can call him, though, if it's important."

"I think it is," he said. "I've been spitting blood, and it's getting worse."

"When did this begin?" I was shocked, and afraid.

He confessed that he had first noticed it almost two years before. He thought it had been caused by exertion when he lifted a big bag of apples up into a pine tree to keep it away from the pigs on Horn Island. A terrific pain almost caused him to drop the sack, and he was seized with a fit of cough-

ing, accompanied by the spitting of blood. However, it passed and while it had occurred at other times, it had not been continuous and he dismissed the incident each time.

I called Dr. Frank, who agreed to meet us at his office immediately. I was dressed for church and heard the bell at St. John's ringing as we turned off Porter Street to the doctor's office.

Dr. Frank was very serious as he listened to Bob's tale about the apples and his belief that he had "ruptured" something. "I want you to go to the hospital at once for some tests," he said. Then he turned to me. "Can you have him at Howard Memorial by one o'clock?"

He spoke as though Bob were a child. Of course I agreed, and on the way home Bob said, "Don't look so stricken. It's probably nothing."

I replied, "Of course, it's just that you never have anything wrong."

I dropped him at his house to get his things and went to the Barn to tell Leif, who was in late pregnancy and lost in lethargy. I picked up a pair of Johnny's pajamas, borrowed an old robe from Peter, rolled the toothpaste and a new toothbrush in a washcloth, dropping them all in a brown paper bag. Bob was waiting for me. He had his glasses from the five-and-ten and three books. His clipboard was under his arm, his disreputable hat on his head. After a stop at a store for a razor and a comb, he got back in the car with a sack bearing the unmistakable outline of a bottle of wine. He had his books: a new two-volume set of *The Rise and Fall of the Roman Empire* and a copy of *The Newcomes* by Thackeray. When we reached the hospital, he tensed and I knew he was considering saying, "No!" But he got out and slowly went in.

When I came home from school the next afternoon, he had already called for me to come get him, and when I picked him up he announced, "Dr. Frank says it's a tumor. He thinks I have lung cancer. He wants me to have surgery, perhaps have the lung removed."

I was speechless, and he continued matter-of-factly, "The man for the surgery is in New Orleans, at Baptist Hospital, but I don't know. . . I'll have to think about it. I just want to go out to Horn Island. I feel like a duck with a lungful of lead."

I reached over and put my hand on his. He pulled away.

"Let me out at my house," he said.

When I drove away, my tears beginning to flow, I saw him getting on his bicycle.

Later in the day Dr. Frank and I talked. He would have no sure diagnosis until after further tests were made in New Orleans. The hospital there had a waiting list and he had put Bob on it. We must be ready to go at any time they called. "If Bob had come to me when it first happened, he might have a better chance. If it is cancer, it is almost sure to have metastasized by now."

I told him what Bob had said about the island, about feeling like a duck. "You know," I quavered, "I almost think it might be best. I wouldn't say that to anyone else, but I know you understand."

Dr. Frank reached over and took my hand. He told me that if Bob decided to go to New Orleans we would have a friend at the hospital. The doctor's son, Smitty, was an intern in surgery there. It was the only comforting thought I had.

I went to school the next day, fear gnawing away at the center of my being. When I came home, Leif was waiting for me. Her baby was about to be born. She was very calm and ready, and proceeded to go to the hospital and have her baby with apparently a minimum of pain and time. Little Moira, as Leif named her, greeted the world great-eyed and calm.

After the baby arrived, I sought out Bob at his cottage but he refused to let me in and refused to talk to me, saying that he was busy sorting some paintings. On Friday the hospital called to say there was room for him and they would keep the space until six in the evening. We needed to leave

immediately. I made my arrangements, and Bob and I were off. He sat cheerfully beside me with his old, battered suitcase purchased in Hong Kong. It was made of paper and contained the same array of mostly borrowed things that we had accumulated for his stay at Howard Memorial in Biloxi, the same books and the same paper bag of cheap wine.

"I'm not sure that this hospital will let you have the wine," I remarked.

"It makes me feel better."

That ended the conversation and was the first and last time he mentioned that he needed to feel better. He sat up and began to enjoy the trip.

"Oh, look out there!" he cried. "Herring gulls all over the place. What an idiot I've been; I haven't looked at the world for weeks. I didn't even know they had come. It's almost winter, isn't it? What's the date?"

"It's the seventeenth of November," I answered. "Next week is Thanksgiving."

"Why, I couldn't have planned it better! You'll be on vacation Thursday and Friday."

It always surprised me when he had any knowledge of my teaching life.

We drove along the beach rapidly. At Gulfport he spotted a Panamanian freighter off the dock and was chatting about bananas when he began to cough violently. His handkerchief was soaked with blood. He leaned his head against the back of the seat, and there was a long silence. Finally, he said, "I was just about to ask you to turn back. I had decided not to go. Now I don't remember why. I suppose we'd better go on. After all, I was born in New Orleans. I might as well die there."

"You're not going to die!" I cried. "You're going there to get well." He didn't answer.

How brown the world! All along Honey Island swamp the broom grass grew rank. Most of the trees had lost their

leaves; only an occasional bit of red or yellow lit the swamp. Now my passenger was absorbed. He was making notes on every small bird or creature; his mind was absorbed with color and form.

"Just look at the sumac and the remnants of goldenrod and ageratum. I've missed the goldenrod on Horn Island, like a carpet of gold, with monarchs all over it," he said.

Once he took up the clipboard lying on the seat between us. I watched a great bare cypress take form, a hawk upon its topmost branch. I was driving fast, determined to get to the hospital by six.

"Slow down" came his voice. "Could you stop for a moment?"

I pulled over to a little side road that he indicated. It wound out over the prairie toward Covington. He got out and walked purposefully down the road, his hat pulled down against the sun like the little boy in his childhood picture. What was he looking for? A curve in the road hid him from view.

When he reappeared, he placed two plump nuts in my hand as he got into the car. "I've gone too far," he said.

"What were you looking for?"

"One of my nullahs," he answered. "On the way to New Orleans on my bike I used to stop along here. There was an old pecan grove on one of those small islands of built-up ground that occur in the prairie. My nullah was a small clear pool in the midst of bullrushes. It even had a water lily in one end. Many a day, pedaling in noonday heat, it saved my life." He laughed. "I just thought it might again."

His hat was pulled low over his eyes. I thought of Billy years before in the bayou. There was nothing for me to say. We drove on, and arrived at the hospital early.

We spent almost two hours at the business office. I had brought my school group health insurance policy. From the beginning I had his name on it, though I never expected him

to use it. Now he became very proud and stubborn. "I don't need your charity. I have money. Here, here is my checkbook."

There was a balance of one hundred and twenty-eight dollars. The processing clerk gave me one of those conspiratorial smiles used for children and imbeciles. It infuriated me, when I should have been grateful for the understanding that took her out of the room so that I could soothe his ruffled feathers.

"Bob," I said quietly, "it's much better to handle it through the insurance company. You don't have to bother keeping track of everything. Please, let's do it my way just this once."

"No, Mother has money if there's not enough in my account."

"Darling, your mother died two years ago," I said. Then, an inspiration. "Do you think I like being an object of charity?"

"What do you mean?" He was interested.

"The Barn," I said. "Don't you remember? Your mother left it to you and you gave it to me. I still live there. How do you think that makes me feel? Besides, I've been paying premiums on that insurance for twenty years and we deserve a little something back on our investment."

At last he consented to sign in with the insurance. The processor returned with a doctor. It was Schmidtty, Dr. Frank's son, as nice as ever.

Schmidtty and Bob told me good-bye. I was not to come back before ten tomorrow. Outside, the lights had come on. The last glow of the sun's setting filled the sky at the end of Napolean Avenue. I became optimistic: all would be well. I drove uptown to St. Charles Avenue to the house of Bob's cousins, Dick and Virginia McConnell. They spoke of Bob's illness in such final tones that my optimism vanished. I went to bed feeling dejected and got to sleep at last, with the words that had comforted me so many times: "God in Bob, God

through Bob, God over Bob. Where God is, there can be no evil."

I got to the hospital by 9:30 the next morning, rested and refreshed. The nurse on the floor greeted me. "Mr. Anderson has finished his tests and is on the sundeck, but Dr. Schmidt wants to see you first." She took me down the hall to a small examining room.

"Good morning." Schmidtty's cheerful greeting matched his smile. "I'm worn out! I don't see how it's possible your husband can be very ill. The tests were extraordinary. He submitted to the bronchoscopy without a struggle. He made the run down the back corridors and up and down the stairs leading me a merry chase. That man is sixty-two and I couldn't possibly keep up with him." He shook his head.

"We took a sample of the tumor. It's very large and must have been bothering him for some time. Everything points to its being malignant.

"We would like to schedule surgery for Wednesday. You could go home tomorrow, straighten out your commitments, and come back Tuesday. The tumor should come out even if it is benign." He paused. "Oh, I must tell you. This hospital regards alcohol as one of the devil's right hands. That bottle of wine almost caused a riot, but I called Dad and asked him what to do. His instant answer? 'Prescribe it, you idiot!' I did. 'One glass at bedtime and as needed by the patient.' "

He roared with laughter and left me.

On the hospital's sun deck Bob was sitting in a chair, busy with his pencil and clipboard. When he looked up and saw me at last, he leaped to his feet. "Come and sit," he said. "It's a beautiful morning. This is a special place. Feel that air! Look at the sparkle!" Then, "How's old Dick?"

"Fine," I said. "They're concerned about you and were terribly kind to me."

He nodded, already back at his sketching. His mouth

twisted in the old way when he worked. He had pulled an empty chair to his corner, and I sat. After a while he asked if the new book had arrived, Edith Sitwell's *Anthology of Poetry*. I had it and I read it to him

We spent almost all of Saturday and Sunday on the sun deck. His mood was good and we passed a weekend happy and intimate. When I left Sunday night to go back to Ocean Springs his parting words were: "We ought to do this more often!"

I came out of the hospital to find the light gone from the sky and my eyes dazzled by the lights of the city. I drove very slowly down the long stretch of the highway toward home. "We ought to do this more often" sang through the sound of the wheels and the motor.

When I reached Shearwater, the Barn seemed to be full of children. Mary was settling Leif and baby Moira into the old studio, and it was good to be home, good to have the family. The future took on a brighter aspect, and I could swear the new baby smiled at her grandmother.

It's a strange thing how we lose ourselves and so much else in a hollow assumption of the role of Martha, busy about many things. I did it now, pouring myself into the roles of mother, grandmother, and schoolteacher. The house was shining when I left late Tuesday evening. I drove furiously back to New Orleans, almost running off the road once to avoid a huge, fat nutria close to the edge. When I reached the hospital, bearing a second volume of *The Newcomes*—and, yes, a bottle of his red wine—I found Bob was not in his room. It was vacant. The nurse, eyeing the wine, looked offended, but told me that "The Rebel" had been moved. Already he had acquired a nickname, partly affectionate, partly descriptive.

Bob had been placed in a room with another patient, I was told, so he would not be alone on the eve of his surgery. When I went into the new room, he was apparently asleep. I went to the bed, bent over, and spoke his name.

Out came his arms. He grabbed me as if he were drowning. In that fierce embrace, I kissed him rather chastely on the forehead.

"Look," I said. "I've brought you a snapshot of the baby."

He gazed at the picture. All he said finally was "Life." His eyes closed. I left the wine and book and made my way to Dick and Virginia McConnell's for the night.

When I arrived the next morning, the hospital was bustling with the activities of shift-changing. It was like the morning traffic in a small city. I met young Dr. Schmidt in the hall. "We're all set for the surgery," he said. "We already have him sedated, so don't be surprised if he's not very responsive to you."

Bob was lying in his bed and I took his hand in mine. We kissed and I put my head on his pillow. He looked at me, smiled, and said again, "We should do this more often." As they rolled him out, there was a jaunty wave of the hand and a kiss blown to me.

In the waiting room Pat, Peter, Mac, and I waited together. When the surgery was over, Schmidtty and the surgeon came to tell us the good news. The surgeon seemed particularly pleased. "You can forget what I said earlier. He's like a young man physically, and as far as we can see is surprisingly clean, no grainy appearance anywhere. We'll keep him in recovery for a few hours."

After this reassurance Mac, Pat, and Peter left and I paced the little waiting room. Three hours passed, when a nurse appeared and told me Dr. Schmidt would like to see me. I followed her. Schmidtty stood beside the stretcher. The figure lying there, defenseless and plugged into myriad machines, was perfectly still except for the faint rise and fall of the chest under the sheets.

"He had a heart arrest," Schmidtty said. "It happened without warning; there wasn't ever a flutter. I had to do a tracheotomy, heart massage. He seems to have stabilized, but

169

I think you'd better stay. We'll put a private duty nurse on from three to eleven."

That evening the nurse secured a reclining chair for me, tucked half in, half out of the entrance to the intensive care cubicle, and I slept until she went off at eleven. Bob woke around twelve and looked about wildly. He was probably in pain and tried to speak. No sound came, and he had no way of knowing why; he knew nothing of the tracheotomy. He grabbed my hand and pulled me down, trying desperately to tell me something. I talked to him and soothed him. He lay still, but his eyes did not close until morning.

The next morning Bob rallied and was moved to a private room, where he became a despot. First, he demanded that the catheter go. It did, and his trips to the bathroom became quite a production, with the nurses in attendance bearing his apparatuses. In two days he was walking, but having a hard time accepting his voicelessness. Schmidtty spent hours explaining that it was not permanent. Bob did not seem comforted. The week wore on, with Bob fighting everything.

By Friday he was off the breathing machine for most of the day; he sat in a chair while I read to him for hours. Saturday the doctors began to talk about his going home, coming back for repair of the tracheotomy later. He surprised them by insisting on staying until it could be fixed. They told me to go home and come back at the end of the week to take him home. That preparation was going to take much thought and planning, so I reluctantly left, Bob urging me to go.

The next morning Schmidtty called me at school to tell me that Bob had suddenly collapsed and was unconscious. They suspected a thrombosis and he thought I'd better come.

"Yes, yes! As fast as I can. Tell him I'm coming," I said. "Tell him even if you don't think he hears you."

The weather changed. A cold drizzle had set in. Mac offered to drive me and I got in the car gratefully. All the way

to New Orleans the rain fell quietly; the last of the leaves dropped steadily, grays and browns and blacks.

When we reached the hospital, I went to Bob's bed, took his hand, and told him, over the clattering of the breathing machine, that I was there. There was no response, just the horrible stertor of his breath. As I stood there frozen, the sound became hollow and I realized that only the machine was breathing. Bob was dead. The doctor, who was standing there, removed the tube.

Bob did not look at peace, only unbearably still. I wanted to howl. Instead I leaned down and whispered, "I love you."

The free spirit that had been within his body had renounced the specter of chains, had preferred the long flight into space.

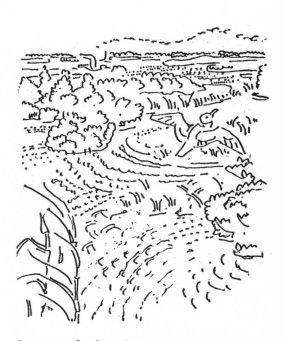

Chapter
Nineteen

I opened the faded green double doors of St. John's Episcopal Church. My grandmother had been instrumental in building it. Louis Sullivan, who made annual visits to Ocean Springs, is believed to have designed it. Blue, red, and yellow light from the panes of glass around the arched windows made patchwork on the old wood. I knelt in a pew at the back and the tears began to flow. I did not feel alone at all. The church was rustling with spirits—my grandmother, my mother, old friends, all the former rectors I had known. The tears were gone when the boys came from the funeral home. They placed the folded catafalque in the door and backed up the hearse. The coffin was slid forward and rolled up the aisle. Over it rested a blanket of russet and red chrysanthemums. One of the young men opened the casket. "No," I cried, "I don't want it open."

"Someone may," he rejoined, looking startled. "Here, let me show you how it works."

And so I came obediently and learned to press the metal plate and slide back the panel. I looked down obliquely,

frightened, upon Bob's face. The young man slipped away and I was left staring. I looked down at his face for a long time. I could not find even a shadow of disappointment on it. I stepped out and stood on the front steps, letting the cold and the wet wash away my regrets.

Then Pat and Peter came in and made me go home to rest. I came back for the funeral service. I remember the minister who read the beautiful words and the terrible ones and then we were all standing in the cemetery and the earnest young man ready to consign the dust to dust and the ashes to ashes and the rain was falling quietly on us and on Bob. Suddenly from down the hill toward the marsh and the silver ribbon of the bayou came a raucous laugh, again and again.

Then our children were laughing, too. We looked at each other. We all knew the voice of the little rail, but it seemed perfectly plausible that Bob had entered into a feathered body to use its voice for a few minutes, to deny the finality of any grave. As the service ended, the rail flew off down the bayou, and we said to ourselves, "There he goes!"

Some time after the funeral I went to his cottage. He had not allowed anyone inside for many months. The water had ceased to run in his sink and his bathroom; he had been bringing it in from a faucet in the yard. The screens were torn and rusted out. All of the windows were broken. The roof and north wall of the bathroom had been crushed by a fallen chinaberry tree. The floors of every room in the house were littered with cigarette butts, empty bottles, and empty beer cans. Old grocery boxes, overflowing with papers, stood gaping all around. Everything was in disorder.

But I began to realize that the place was bursting with treasures. The hearth and surrounding floor were littered with hundreds of watercolors. The fireplace, full of ashes, attested to his habit of culling his work. It was impossible to guess how much he had destroyed during his lifetime, but what was there was overpowering: all the work he had done, over years and years, concentrated in one spot—work from his student days to the last sketches I had brought from the hospital. There in the dirty, crumbling cottage was a truly rare thing: almost the complete works of an artist.

There were thousands of small watercolors on typing paper. Executed during the last sixteen years of his life, they were dizzying in their intensity. I found, as well, large watercolors from an earlier time, the years at Oldfields. There were piles of pen-and-ink drawings, crayon drawings, pencil drawings. Many were sketches and many were detailed studies, with careful color notes that he made in situ, perhaps in some blind up to his waist in swamp water, drawing in a fury of creation.

There were other special things: the daily calendar drawings from Oldfields, block-printed books for the children, and a treasure trove of designs for plates to be done in the Pottery. There were wood carvings, decorated pottery, and a few oils.

Nor was this all. Bob kept records of his trips, which he called logs. I found them stuffed away in an old-fashioned safe where apparently he tossed them when he came in from Horn Island. The logs constitute a very personal record of an artist's inspirations and discoveries. They were written simply and attest almost more poignantly than the paintings to the intensity of his living, his total involvement with his environment. Through them blows the fresh island wind. When I read them I tasted the salt and squinted my eyes against the glare.

Later my sister and I opened the door of a small room

that had been hidden away from us. Bob had kept a padlock on the door. When we looked in, we found that a miracle had taken place. Bob had painted a luminous mural on the walls and ceiling, recording the progress of light through the hours of a day. On the east wall, morning breaks upon the Gulf Coast. In a glade in cut-over land at the first glorious burst of light, night creatures linger in the shadows and sandhill cranes fly up to greet the sun. On the south wall, daylight has come. A bluff above the sea is bathed in the radiant light, a rainbow arches across the sky, and ibises in a wheeling flight catch the sun across their wings. On the west wall, shadowy and mystical, evening light illumines the patterns of ivy and moonflower, and black skimmers sweep across the sky.

Great moths on the north wall, dark and luminous, express the night's full magic. On the plastered chimney, a girl figure represents the river, the Mississippi. From her head spring antlerlike tributaries. At her feet are a stokesia, a wood lily, a deer, a turtle, and a rabbit.

When my sister first went in, she exclaimed, "Creation at sunrise!"

Indeed, the room is full of the presence of the Creator— not the artist, although he is surely there, but God. I found among Bob's papers Psalm 104, which he had copied carefully. Bob's worship took the form of praise, praise of the wonder and beauty of all nature, including man, whose sublimity he never doubted.

All that we found in the cottage is testimony to his realization, his torment, and his exultation. It was eloquent testimony speaking to time itself. The spiral has no end.

 I asked Pat and Peter to take me out to Horn Island in the early summer of the next year. I was not quite clear on my reason for the trip. What difference was it going

to make? Bob had told me that his home was gone; his sand dune, safe haven for so many years, had been washed away by Hurricane Betsy. But I wanted to go there where he had been.

When school was over at last, Peter and Pat took me to the island. As we approached the beach, Pat asked, "Do you want to be alone?"

"Yes," I answered, shocked by the strange sound of the word.

"Then Peter and I will let you off and go down to the west end and fish. You'll probably have all day."

She packed a lunch for me and Peter rowed me into the beach. I waded ashore with such a feeling of expectancy; I stood on the sand until they were gone. All the beauty of the island closed around me. The sand was as white as ever. The water sparkled clear. The wind sang in the pines. The rosemary bushes patterned the dunes. The birds flew. The rabbits made their prints in the sand. How could this be when he was not here to realize?

I walked the beach and came to that remnant of the dune where he had camped. Climbing the slant, which was covered in the browned needles of a small dead pine, I felt such sorrow, such yearning that I slid down against the narrow trunk. For a time I sat, a blank sorrow gripping me, head bowed with blinded eyes. After a while I became aware of a shining, and looking down the slope I saw the lily pond sparkling full in the sun. Suddenly I felt his presence, this man of light who translated into visual form the 104th Psalm, Ikhnaton's *Hymn to the Sun*, upon the walls of his house; this man whose heart actually beat faster at the words in Genesis, "Let there be light"; this man who pursued in myth and history the Sun God's presence; this man whose life's work is full of light. I was with him.

The music that I was hearing did not register at first, but the phrase came, again and again: Beethoven, of course—wasn't it the opening notes of the *Seventh*? I sat up straight. A

flight of redwings slid across the space. They lit close. These were his friends, returned from winter travels. The three notes that they sang over and over were the song they had shared with him.

The terrible sense of loss dissipated. I knew the continuity of life and I was released from my sorrow. I felt him close as I walked back down the beach. I saw that the sun was getting low in the west. Peter's boat was just visible coasting down the beach. The need to say good-bye was so strong that I found myself turning as if someone stood beside me. When I saw Peter rowing in, I did say it. "Good-bye, Bob."

I left with the feeling strong within me that I would always find him when I came back to Horn Island.